THE BOOK OF MECHTILDE

THE BOOK OF MECHTILDE

ANNA RUTH HENRIQUES

ALFRED A. KNOPF NEW YORK

1997

THIS IS A BORZOI BOOK

PUBLISHED BY ALFRED A. KNOPF, INC.

Copyright © 1997 by Anna Ruth Henriques

All rights reserved under International and Pan-American Copyright Conventions..

Published in the United States by Alfred A. Knopf, Inc., New York.

Distributed by Random House, Inc., New York.

http://www.randomhouse.com/

Grateful acknowledgment is made to David A. Loggie for producing the transparencies

from which this book was made.

Library of Congress Cataloging-in-Publication Data

Henriques, Anna Ruth, [date]

The book of Mechtilde / by Anna Ruth Henriques — 1st ed.

 p. cm.

ISBN 0-375-40023-0 (hc)

1. Henriques, Anna Ruth, [date] Book of Mechtilde.

2. Illumination of books and manuscripts—History—20th century.

3. Henriques, Sheila Mechtilde. I. Title.

ND3410.H46A4 1997

745.6'7'092—dc21 97-2809 CIP

MANUFACTURED IN THE UNITED STATES OF AMERICA

FIRST EDITION

FOR TWO MOTHERS

Mine
Sheila, whose passing life gave birth to this book

and Lara's
Jane, who delivered it to all

INTRODUCTION

The Book of Mechtilde is based
on the Book of Job. The main charac-
ter, Mechtilde, replaces Job, who has
traditionally been regarded as a
model of virtue; Job exemplifies
the good person who is punished by
misfortune and sickness, but who is
rewarded for his patience and faith.
Mechtilde, better known as Sheila
Mechtilde Henriques, née Chong, also
lived a virtuous life. Unlike Job, who
regains all that he has lost,
Mechtilde's reprieve from suffering
came with death. On October 31,
1978, after nine years of illness, she
died of cancer. She was my mother.

THE JOURNEY

Late one night, at my grandparents' home on the southeast coast of rural Jamaica, nestled into the foothills of the Blue Mountains overlooking the Caribbean Sea, I began *The Book of Mechtilde*. For a long time, I had been thinking about creating a memorial of a sort to my mother. I was still searching for the ideal framework and direction. That evening, after jotting in a notebook yet another fragment of my memory of my mother, I picked up my Bible, given to me in observance of a long-ago rite of passage. A decade before, I had placed the corsage I had received that day between the pages of the Bible, a sentimental gesture of my early adolescent years. I now extracted the fragile, dried rose, crisp and crumbling with age, and put it in the bottom of the Bible's clothbound box. I lifted the ribbon marking the page, and as fate would have it, the first page I fingered began the Book of Job.

The idea emerged instantaneously. All that remained was to complete the work. I was in an ideal setting at my grandparents' home. I spent my days painting on an old wooden desk in the Schoolroom, the name given to the small freestanding concrete-block structure at the back of the house where my father and his brother had been taught by my grandmother. During the evenings I would return to the house to sit at the dining table, after my grandmother had retired to an armchair with a book or her knitting and my grandfather to his seat in front of the television. He would tune in to a satellite roaming the nighttime sky, and crank up the volume to capacity, ensuring immersion in otherwise only semi-interesting programs. The television provided an ambience of activity. Otherwise, the countryside was quiet, exceedingly so, for a nation of social and sociable creatures, where silence resounded as discord, serenity as noise.

With the television roaring and flashing forth its eerie blue light, I would imprint the biblical text in gold ink around each illustration painted earlier that day. I would glance up now and then to see my grandfather's head drop to his shoulder as he dozed, then the shudder as he caught himself, cheeks jostling his chins as he shook to regain a semblance of consciousness and catch the remaining portion of the program. He was my company at this late hour, my human presence and solace in the shifting shadows of the petrifying vacuum of night. By this time, my grandmother had already gone to bed with her shortwave radio and a book. When my eyes would no longer focus, and my grandfather could no longer rouse himself from (albeit shallow) sleep, I'd pack my paintings, rise, and take the remote from his motionless hand. In the sudden ensuing silence with the TV now off, he'd stir, enough to register this signal for bedtime. While I turned off the few remaining lights, he'd shift his weight to his feet and lift himself from his chair, then rely on the somnambulist's shuffle to transport him to bed.

During the next half hour each evening, before sleep overwhelmed me, I would write and revise the text to the book in a spiral-bound notebook that has long since been lost. Writing in solitude but never alone, always as if in my grandparents' presence. From my bedroom, one wall away from them, I could hear the drone and crackle of the radio, knowing I would hear it all night as my grandmother had fallen asleep with it standing on her chest, antenna upright receiving broadcasts from all over the world. I could feel the vibrations of my grandfather's snore as he rumbled through the night, with seldom a lull in his nocturnal breathing. Then their dog would go for his fleas, snuffling after them as they hopped around in his fur, nipping his skin. Now and then, I painted and wrote elsewhere—the book travelling with me as a stack of images and text. Finally, when it was finished, I showed the illustrations and read the words aloud to my grandmother and my aunt. I recited, they listened, we wept.

THE BOOK OF MECHTILDE

MANY YEARS AGO,

in the Land of Jah, there lived a good
woman named Mechtilde. This woman had
one fine husband for whom she bore three
daughters. Together, they owned a small
plot of earth, upon which sat a house and
a grand mango tree, amongst the oldest
of trees in the Land.

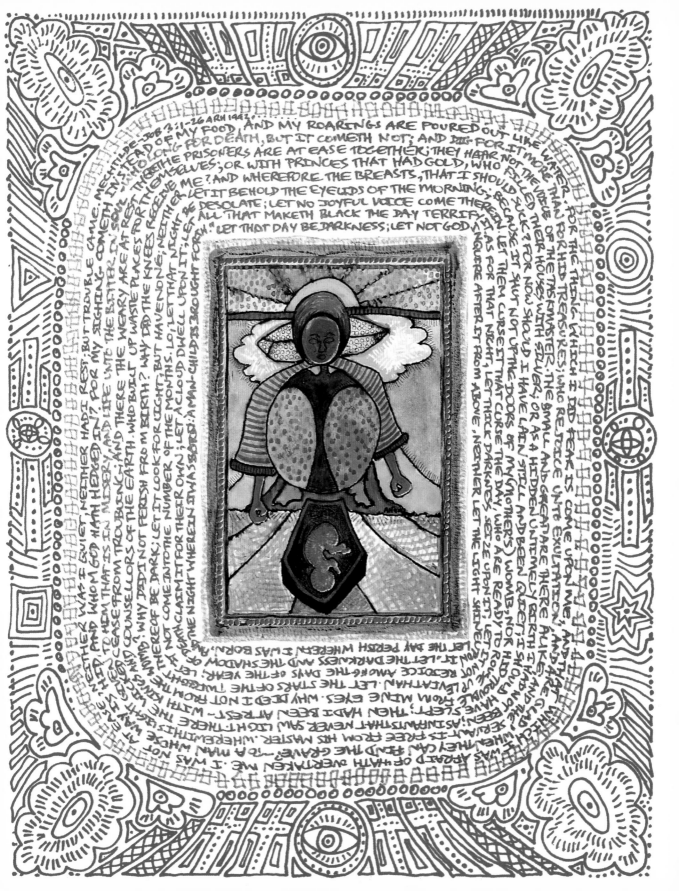

Each day, under the mango tree, Mechtilde used to sit and hold court. She would invite her daughters to her side, her dogs to her feet, and her many friends to the very best chairs surrounding her. They would eat and drink, laugh and cry, at the joy that this woman brought them.

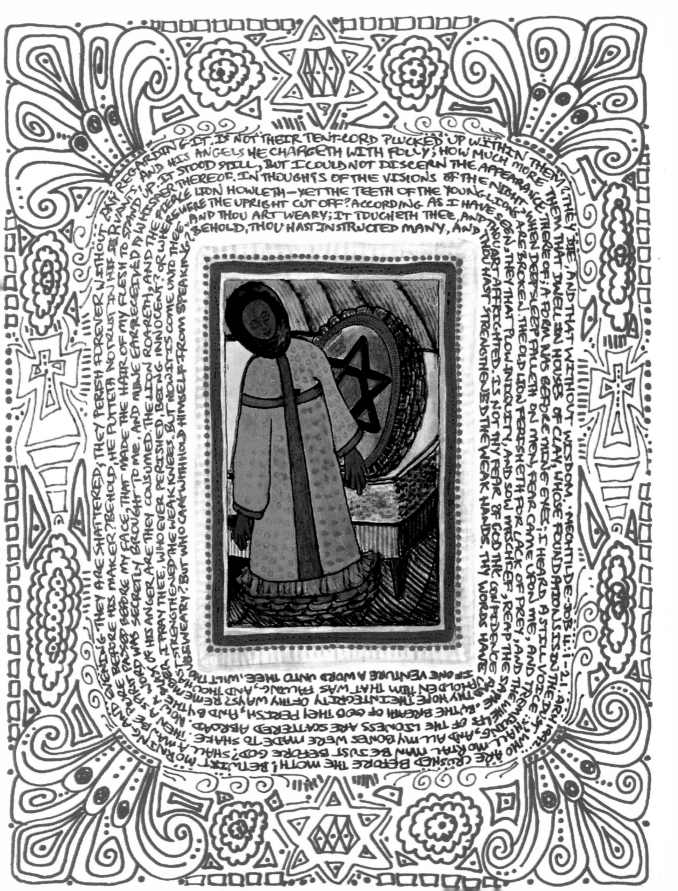

REGARDING IT. IS NOT THEIR TENT-CORD PLUCKED UP WITHIN THEM? THEY DIE, AND THAT WITHOUT WISDOM. "MECHTILDE-JOB III:1-21. ARM IRAQI AND HIS ANGELS HE CHARGETH WITH FOLLY; HOW MUCH MORE THEM THAT DWELL IN HOUSES OF CLAY, WHOSE FOUNDATION IS IN THE DUST, WHICH ARE STAND STILL, BUT I COULD NOT DISCERN THE APPEARANCE THEREOF: A FORM WAS BEFORE MINE EYES; I HEARD A STILL VOICE, CRUSHED BEFORE THE MOTH? BETWIXT MORNING THEREOF. IN THOUGHTS OF THE VISIONS OF THE NIGHT, WHEN DEEP SLEEP FALLETH ON MEN, FEAR CAME UPON ME, AND TREMBLING, WHICH MADE ALL MY BONES TO SHAKE. THEN A SPIRIT PASSED BEFORE MY FACE, THAT MADE THE HAIR OF MY FLESH TO STAND UP. IT STOOD STILL, BUT I COULD NOT DISCERN LION HOWLETH—YET THE TEETH OF THE YOUNG LIONS ARE BROKEN. THE OLD LION PERISHETH FOR LACK OF PREY, AND THE STOUT HEARTED ARE WHERE THE UPRIGHT CUT OFF? ACCORDING AS I HAVE SEEN, THEY THAT PLOW INIQUITY, AND SOW WICKEDNESS, REAP THE SAME. BY AND THOU ART WEARY; IT TOUCHETH THEE, AND THOU ART AFFRIGHTED. IS NOT THY FEAR OF GOD THY CONFIDENCE, AND THE BEHOLD, THOU HAST INSTRUCTED MANY, AND THOU HAST STRENGTHENED THE WEAK HANDS. THY WORDS HAVE

ANT WITHOUT ANY REGARDING IT. THEY PERISH FOREVER WITHOUT ANY REGARDING IT. IS NOT THEIR TENT-CORD SERVANTS IN HIS SERVANTS, HE PUTTETH NO TRUST IN HIS SERVANTS; BEHOLD, HE PUTTETH NO TRUST IN HIS SERVANTS, EXERCISED BROUGHT TO ME, AND MINE EAR RECEIVED A WHISPER THEREOF. IN THE LION ROARETH, AND THE VOICE OF THE FIERCE THE OLD LION PERISHETH. THE LION ROARETH, AND THE FIERCE BEING INNOCENT? OR WHERE WERE THE RIGHTEOUS WHO EVER PERISHED, BEING INNOCENT? OR WHERE THE WEAK KNEES. BUT NOW IT IS COME UNTO THEE, AND UPHOLDEN HIM THAT WAS FALLING, AND THOU HAST STRENGTHENED WHO ARE JUST BEFORE GOD? SHALL A MAN BE MORE PURE THAN HIS MAKER? BEHOLD, HE PUTTETH NO TRUST IF ONE VENTURE A WORD UNTO THEE, WILT THOU BE GRIEVED? BUT WHO CAN WITHHOLD HIMSELF FROM SPEAKING? AND THY HOPE THE INTEGRITY OF THY WAYS? REMEMBER, BY THE BREATH OF GOD THEY PERISH, AND BY THE LIKE LIPS OF THE LIONESS ARE SCATTERED ABROAD. BY THE BREATH OF GOD THEY PERISH, AND BY THE BREATH NOW A WORD WAS SECRETLY BROUGHT TO ME, AND MINE BY THE BLAST OF HIS ANGER ARE THEY CONSUMED. THE LION ROARETH, AND THE VOICE OF THE FIERCE THEY ARE SHATTERED; THEY PERISH FOREVER

At nightfall, all would depart and the devoted helpers of Mechtilde would arrive to attend to her. They would wash her, change her clothing, and prepare and lay an elaborate meal before her. Then her beloved husband would take their place, and fulfill the period of visiting.

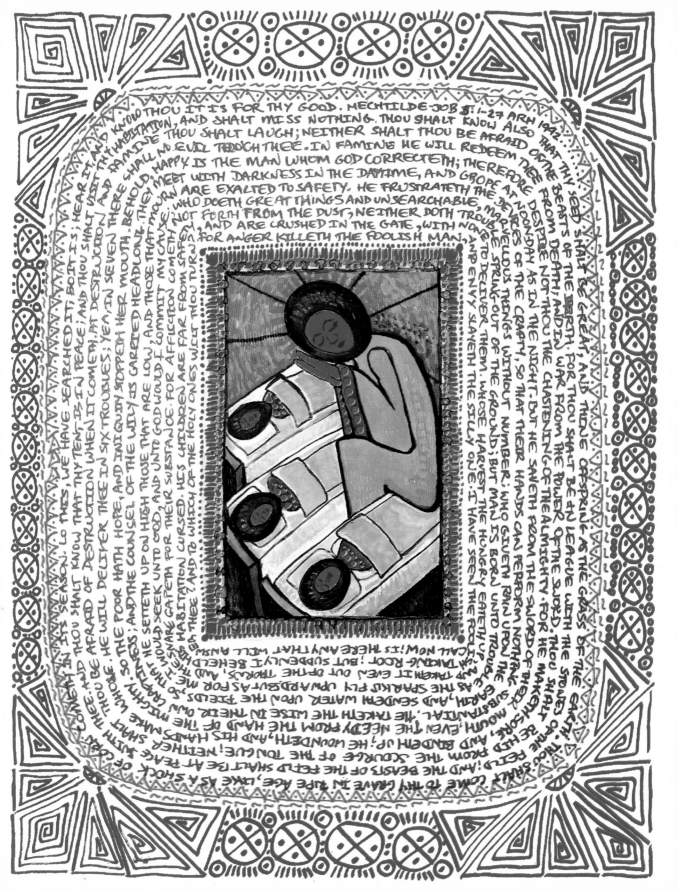

Each visit, however, weakened Mech-
tilde. In spite of the joy the visits
brought her, they sacrificed her strength,
of which she had little remaining. For
Mechtilde was ill, stricken many years
before by a disease. This disease ate
at her flesh, slowly and silently
devouring her body. It was a disease
that knew no cure.

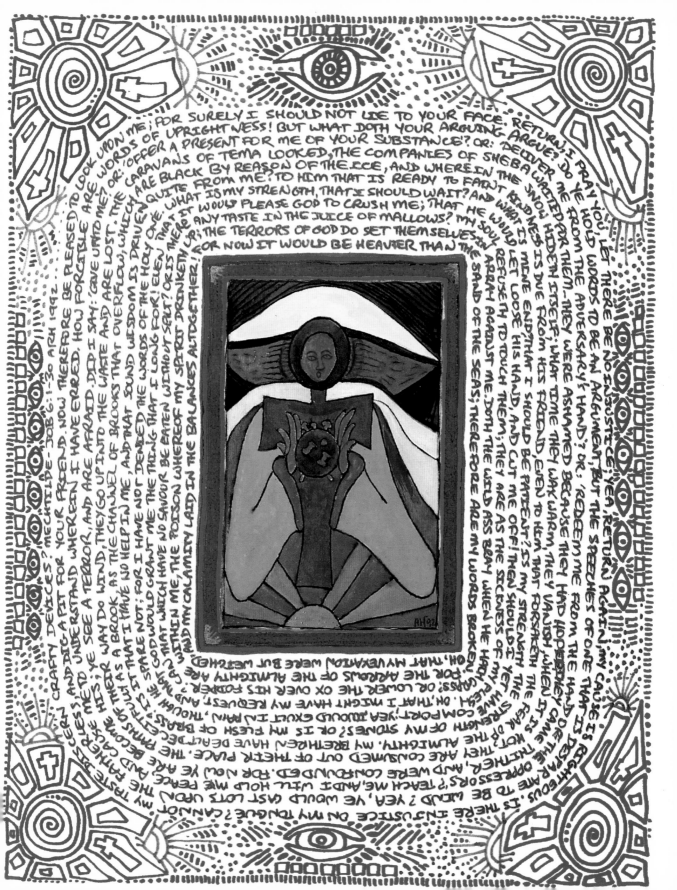

UPON ME; FOR SURELY I SHOULD NOT LIE TO YOUR FACE. RETURN, I PRAY YOU, LET THERE BE NO INIUSTICE; YEA, RETURN AGAIN, MY CAUSE IS RIGHTEOUS. WORDS OF UPRIGHTNESS! BUT WHAT DOTH YOUR ARGUING ARGUE? DO YE HOLD WORDS TO BE AN ARGUMENT, AND THE SPEECHES OF ONE THAT IS DESPERATE, WHICH ARE AS WIND? OR: 'OFFER A PRESENT FOR ME OF YOUR SUBSTANCE'? OR: 'DELIVER ME FROM THE ADVERSARY'S HAND'? OR: 'REDEEM ME FROM THE HAND OF THE OPPRESSORS'? ARE BLACK CARAVANS OF TEMA LOOKED, THE COMPANIES OF SHEBA WAITED FOR THEM.—THEY WERE ASHAMED BECAUSE THEY HAD HOPED; THEY CAME THITHER BY REASON OF THE ICE, AND WHEREIN THE SNOW HIDETH ITSELF; WHAT TIME THEY WAX WARM, THEY VANISH; WHEN IT IS HOT, THEY ARE CONSUMED OUT OF THEIR PLACE. THE PATHS QUITE FROM ME: TO HIM THAT IS READY TO FAINT KINDNESS IS DUE FROM HIS FRIEND, EVEN TO HIM THAT FORSAKETH THE FEAR OF THE ALMIGHTY. MY BRETHREN HAVE DEALT DECEITFULLY WHAT IS MY STRENGTH, THAT I SHOULD WAIT? AND WHAT IS MINE END, THAT I SHOULD BE PATIENT? IS MY STRENGTH THE STRENGTH OF STONES? OR IS MY FLESH OF BRASS? IS IT WOULD PLEASE GOD TO CRUSH ME; THAT HE WOULD LET LOOSE HIS HAND, AND CUT ME OFF! THEN SHOULD I YET HAVE COMFORT; YEA, I WOULD EXULT IN PAIN, THOUGH IS THERE ANY TASTE IN THE JUICE OF MALLOWS? MY SOUL REFUSETH TO TOUCH THEM; THEY ARE AS THE SICKNESS OF MY FLESH. OH, THAT I MIGHT HAVE MY REQUEST, AND THAT ROOT UP; THE TERRORS OF GOD DO SET THEMSELVES IN ARRAY AGAINST ME. DOTH THE WILD ASS BRAY WHEN HE HATH GRASS? OR LOWER THE OX OVER HIS FODDER? IT FOR NOW IT WOULD BE HEAVIER THAN THE SAND OF THE SEAS; THEREFORE ARE MY WORDS BROKEN. FOR THE ARROWS OF THE ALMIGHTY ARE WITHIN ME, THE POISON WHEREOF MY SPIRIT DRINKETH UP; OH, THAT MY VEXATION WERE BUT WEIGHED,

FOR NOW IT WOULD BE... IS THERE INIUSTICE ON MY TONGUE? CANNOT MY TASTE DISCERN CRAFTY DEVICES? MECHTILDE · JOB 6: 1-30 ARH 1992. CAUSE YE TO BE WIND? YEA, YE WOULD CAST LOTS UPON THE FATHERLESS, AND DIG A PIT FOR YOUR FRIEND. NOW THEREFORE BE PLEASED TO LOOK UPON ME; FOR SURELY I SHOULD NOT DISCERN ME TO UNDERSTAND WHEREIN I HAVE ERRED. HOW FORCIBLE ARE UPRIGHT WORDS! WHAT DOTH YOUR ARGUING REPROVE, SEEING TEACH ME, AND I WILL HOLD MY PEACE; AND CAUSE THE PATHS OF THEIR WAY DO WIND, THEY GO UP INTO THE WASTE AND ARE LOST. THE OPPRESSORS? ARE NOT THEY ARE TURNED ASIDE; YE SEE A TERROR, AND ARE AFRAID. DID I SAY: 'GIVE UNTO ME'? OR: 'GIVE A REWARD FOR ME OF YOUR SUBSTANCE; IT THAT OVERFLOW, WHICH ARE BECOME A BROOK, AS THE CHANNEL OF BROOKS THAT OVERFLOW, WHICH ARE DRIVEN AWAY; STRENGTH OF THE ALMIGHTY. MY BRETHREN HAVE DEALT DECEITFULLY AS A BROOK, AS THE STREAM OF BROOKS THEY PASS AWAY; OR: 'DELIVER SPARE NOT: FOR I HAVE NOT DENIED THE WORDS OF THE HOLY ONE. WHAT IS MY STRENGTH, THAT I SHOULD WAIT? AND THAT SOUND WISDOM IS DRIVEN QUITE FROM ME: TO HIM THAT IS READY WITHIN ME, AND MY CALAMITY LAID IN THE BALANCES ALTOGETHER!

Until now, Mechtilde had considered herself a lucky woman. She had been born into a family of four brothers and four sisters, and fine parents, though of humble means. Her father had come from the East, bringing with him the blessings of harmony and balance. Her mother had come from a multitude of origins, bringing with her the blessings of tolerance and peace. Together, they raised their offspring well, bestowing upon them open minds and even hearts.

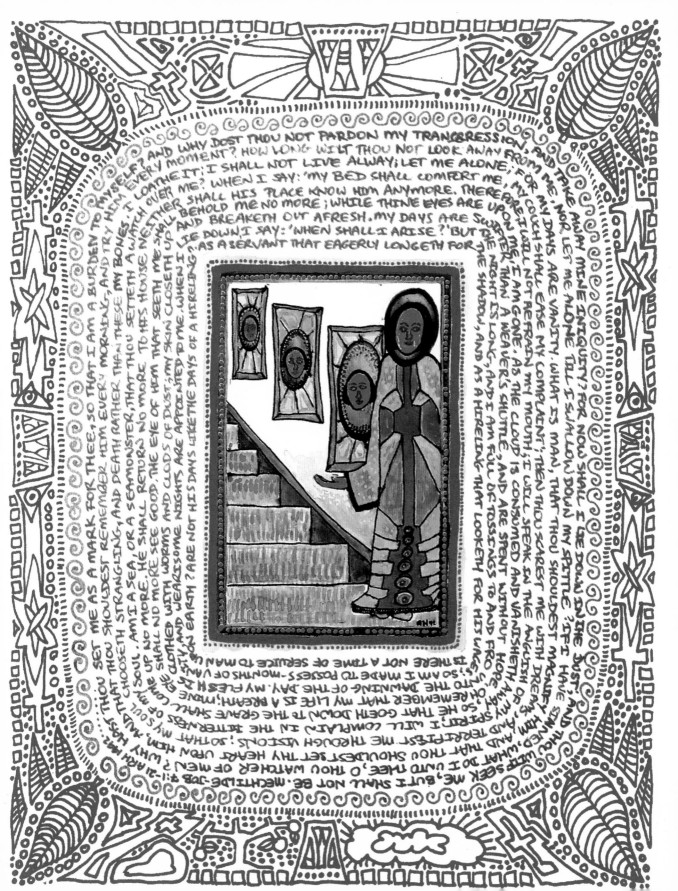

AND WHY DOST THOU NOT PARDON MY TRANSGRESSION, AND TAKE AWAY MINE INIQUITY? FOR NOW SHALL I LIE DOWN IN THE DUST; AND THOU SHALT SEEK ME, BUT I SHALL NOT BE.

EVERY MOMENT? HOW LONG WILT THOU NOT LOOK AWAY FROM ME, NOR LET ME ALONE TILL I SWALLOW DOWN MY SPITTLE? IF I HAVE SINNED, WHAT DO I UNTO THEE, O THOU WATCHER OF MEN? WHY HAST

I LOATHE IT; I SHALL NOT LIVE ALWAY; LET ME ALONE, FOR MY DAYS ARE VANITY. WHAT IS MAN, THAT THOU SHOULDEST MAGNIFY

OVER ME? WHEN I SAY: 'MY BED SHALL COMFORT ME, MY COUCH SHALL EASE MY COMPLAINT'; THEN THOU SCAREST ME WITH DREAMS

SHALL HIS PLACE KNOW HIM ANYMORE. THEREFORE I WILL NOT REFRAIN MY MOUTH; I WILL SPEAK IN THE ANGUISH OF

BEHOLD ME NO MORE; WHILE THINE EYES ARE UPON ME, AND I AM GONE. AS THE CLOUD IS CONSUMED AND VANISHETH

AND BREAKETH OUT AFRESH. MY DAYS ARE SWIFTER THAN A WEAVER'S SHUTTLE, AND ARE SPENT WITHOUT HOPE

LIE DOWN, I SAY: 'WHEN SHALL I ARISE?' BUT THE NIGHT IS LONG, AND I AM FULL OF TOSSINGS TO AND FRO

AS A SERVANT THAT EAGERLY LONGETH FOR THE SHADOW, AND AS A HIRELING THAT LOOKETH FOR HIS WAGES

THOU SET ME AS A MARK FOR THEE, SO THAT I AM A BURDEN TO MYSELF? THAT THOU SHOULDEST REMEMBER HIM EVERY MORNING, AND TRY HIM EVERY MOMENT? CHOOSETH STRANGLING, AND DEATH RATHER THAN THESE MY BONES. AM I A SEA, OR A SEA-MONSTER, THAT THOU SETTETH A WATCH OVER ME? HE SHALL RETURN NO MORE TO HIS HOUSE NEITHER SHALL NO MORE SEE GOOD. THE EYE OF HIM THAT SEETH ME SHALL CLOTHED WITH WORMS AND CLODS OF DUST; MY SKIN CLOSETH UP YEARISOME NIGHTS ARE APPOINTED TO ME. WHEN I IS THERE NOT A TIME OF SERVICE TO MAN UPON EARTH? ARE NOT HIS DAYS LIKE THE DAYS OF A HIRELING? 'SO AM I MADE TO POSSESS—MONTHS OF VANITY, INTO THE DAWNING OF THE DAY, MY FLESH IS 'OH REMEMBER THAT MY LIFE IS A BREATH; MINE 'SO HE THAT GOETH DOWN TO THE GRAVE SHALL MY SPIRIT; I WILL COMPLAIN IN THE BITTERNESS OF AND TERRIFIEST ME THROUGH VISIONS; SO THAT THY HAND THAT THOU SHOULDEST SET THY HEART UPON HIM, AND

—MECHTILDE—JOB 4:11-21 ARE NOT

Furthermore, Mechtilde had been graced with great beauty, and she travelled far and wide to represent Jah in other nations. All loved her. Suitors, besotted by her beauty, fell at her feet. Women bore her no grudge, but blessed her. She captivated both the elderly and children, who clung to her. Stories were written about her, and songs were sung in her honor.

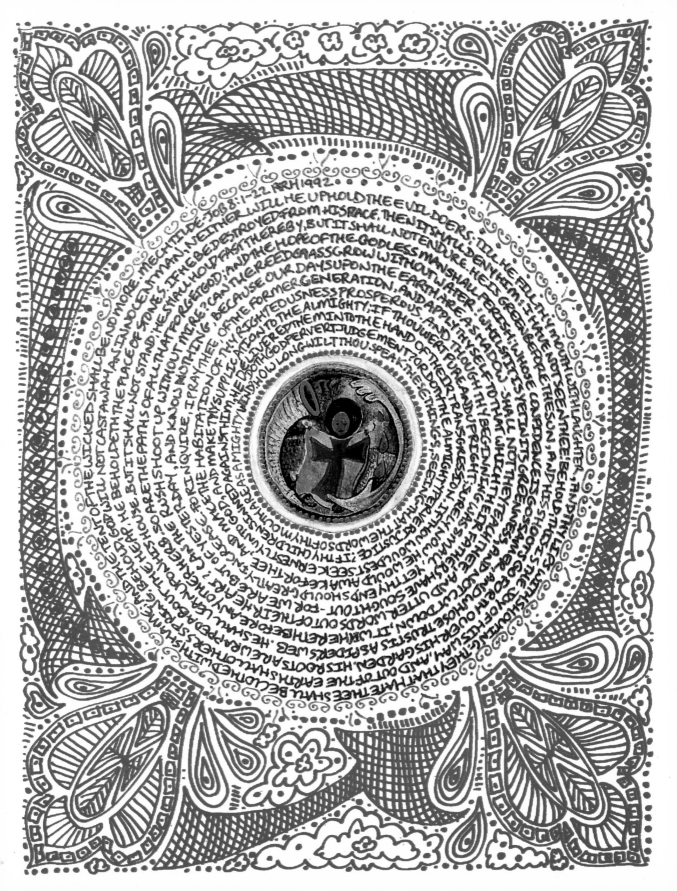

Mechtilde lived in a land of songmakers. The people expressed themselves through music which, in turn, became the heart-beat of the Land. In times of joy, the music rejoiced. In times of sorrow, the music wept. And Jah knew both sounds of thanksgiving and of lamentation, since times in the Land were tumultuous.

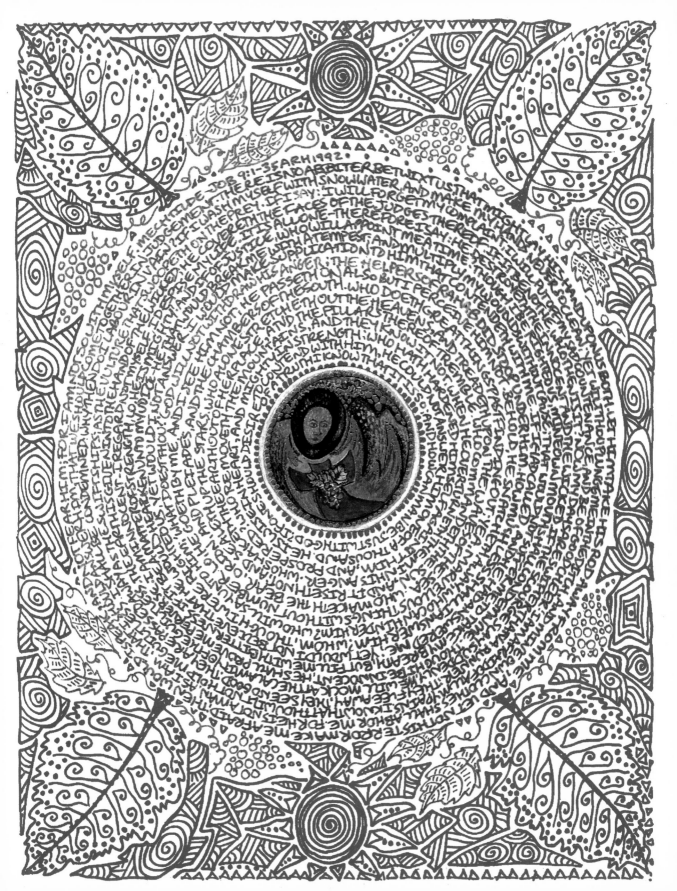

Jah had only recently become a nation separate from all other nations. The people had worked hard to gain the Land for their own. Most had been exiled from other lands, and knew no return. Bonded by exile, they grew to love Jah and claim Jah for their own. Others opposed them but they worked even harder and wavered not from their path. The satisfaction that they gained was great, as was their prediction of greater reward.

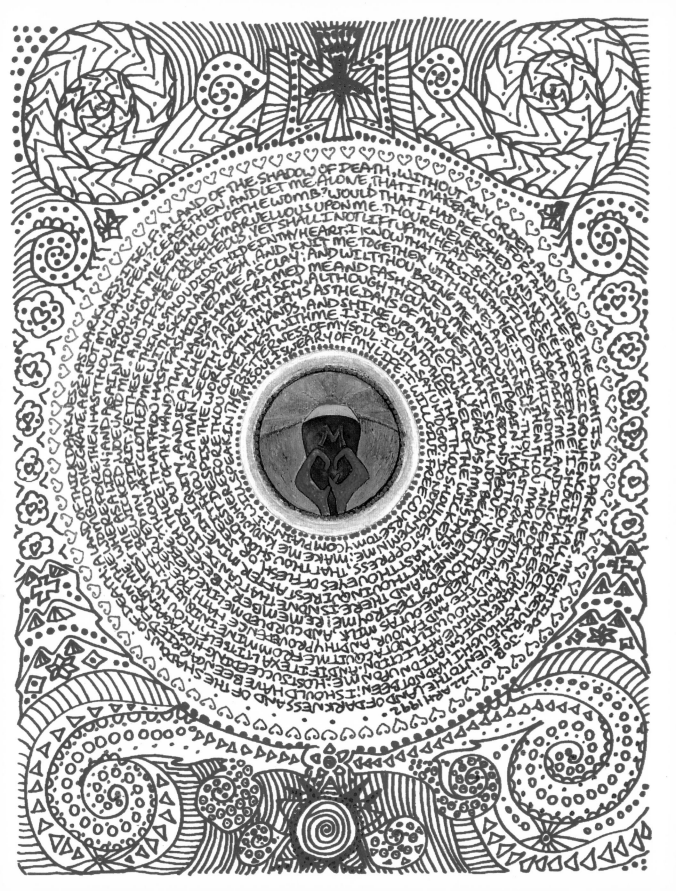

Jah's people were a superstitious people and put much faith in the power of divination. Those who were bestowed with this power were mostly women who came to be known as Wise Women. Through earthly deeds and practices, they foretold the future and, through divine inspiration, they directed people's lives. They were held in awe and wonderment, and visited by many.

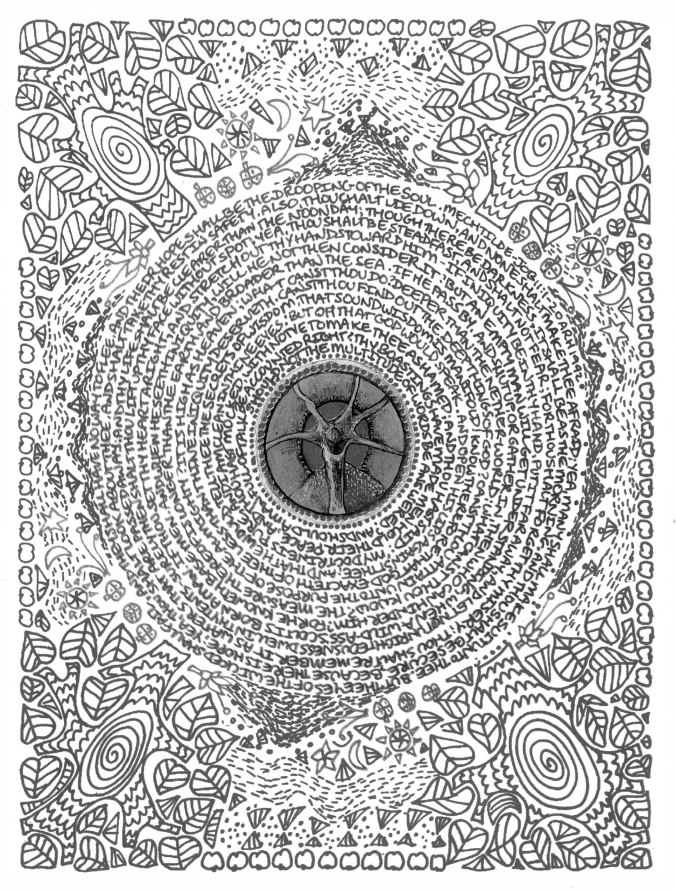

Mechtilde was amongst those who went to visit a Wise Woman. The Wise Woman took her aside and gave her tea to drink. When Mechtilde finished drinking, she took the cup from her. She peered into it, then closed her eyes. Speaking softly, she told Mechtilde that within one week she would meet her future husband, and within a year would marry him. She spoke of much joy that she saw ahead, but did not speak of the impending sadness to which she had shut her eyes.

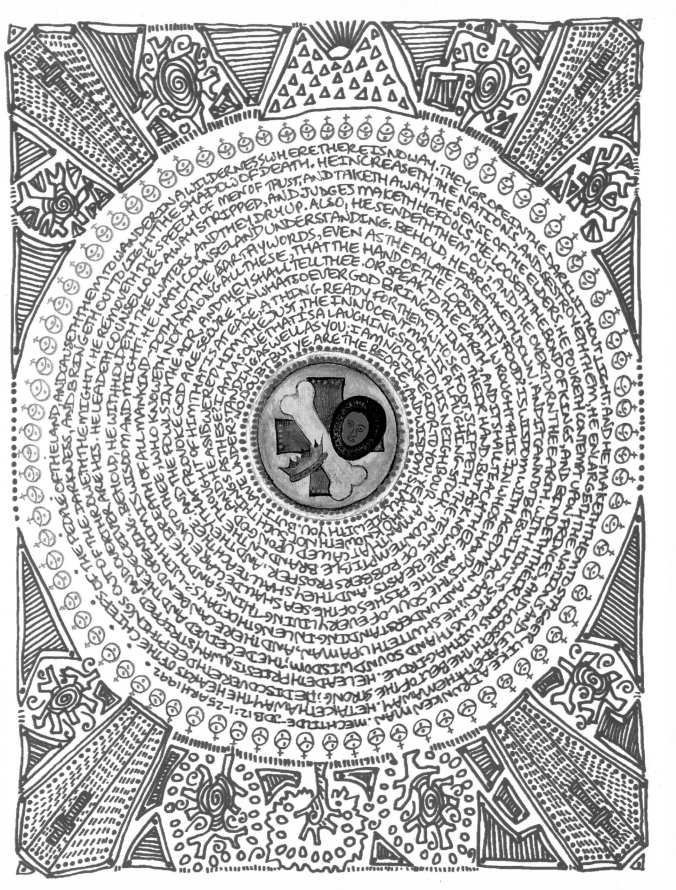

Mechtilde returned home filled with contentment and inner peace. She had hoped for a family and one was now in store for her. Soon, all that the Wise Woman spoke of came to pass. She met her future husband that week, and by year's end they were married. Together, they acquired their house and plot of land with the aged tree. Their friends were plentiful and their families prosperous. The tree bore in abundance and Mechtilde gave birth to three daughters.

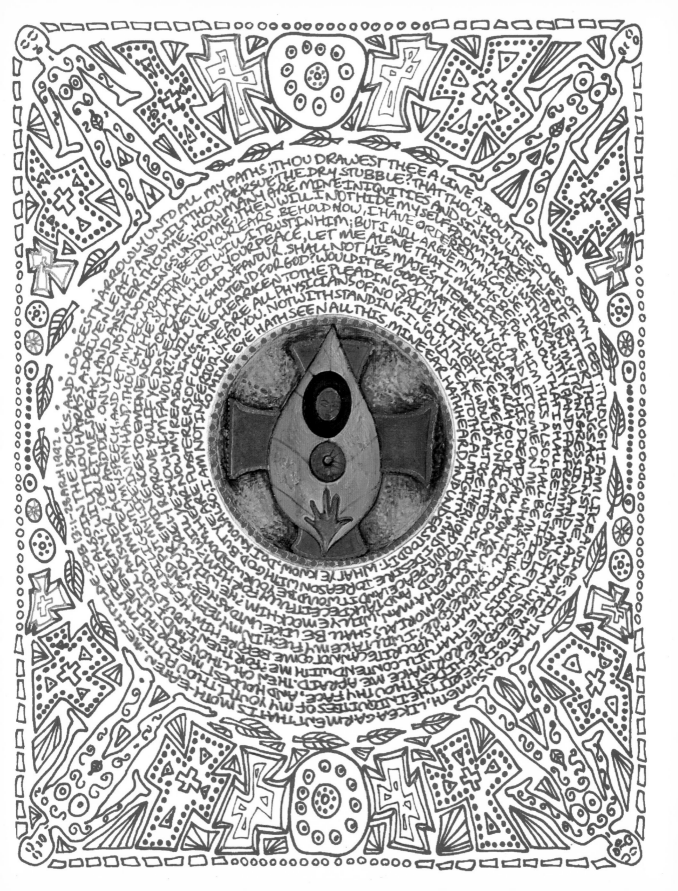

Then misfortune struck. Mechtilde discovered within her the terrible disease. Her health deteriorated, taking with it her womanhood. She fought with courage and faith, but few believed she would survive. Fearful of the knowledge of the future, she did not dare visit the Wise Women of the Land. Instead, Mechtilde relied on the strength of her will and battled bravely with the terrible disease. She drew on the fortitude of her family and friends and forced the disease into remission.

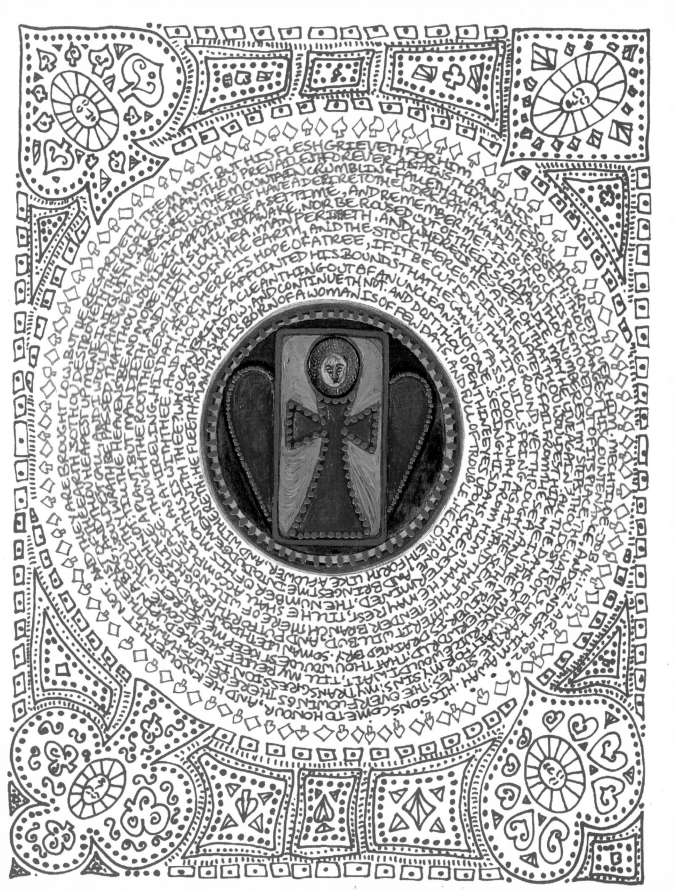

When it seemed that Mechtilde had regained good health, the fortunes of Jah took a turn for the worse. In the early years of the Land, two tribes had risen to prominence. These two tribes vied for leadership of the Land. Before, they had used rhetoric to win the hearts of the people. Now, they lifted up swords against one another and set their followers to war. Suddenly, the future of Mechtilde's family and friends looked grim, and those who could leave departed the Land. They took with them their fortitude, depleting the strength of her will.

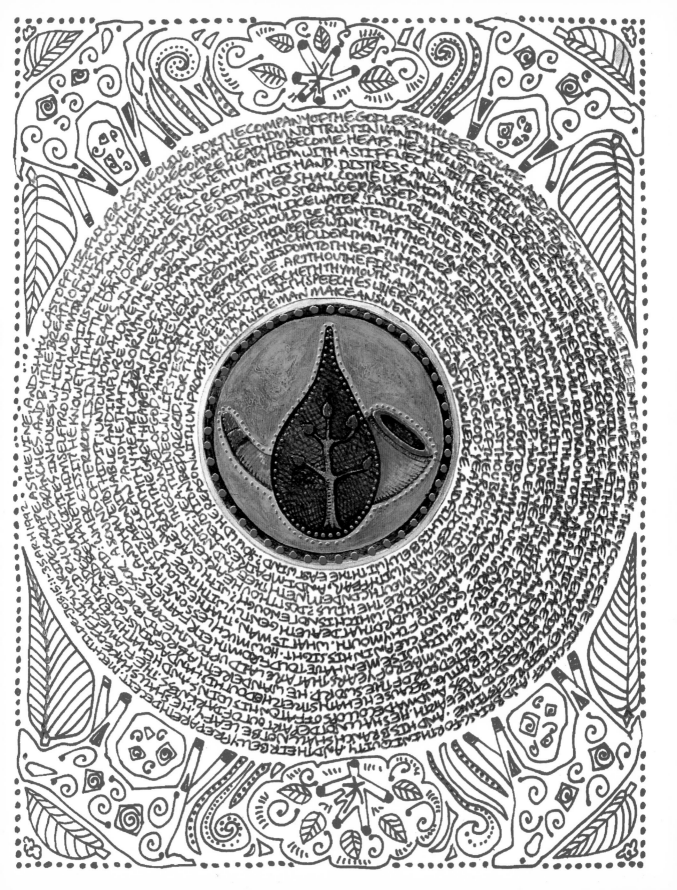

The disease resurfaced. As Mechtilde's body began to fight the illness, the war with Jah worsened. Soon, the battle raged on either front. The invasive disease spread slowly and, like the divided factions of Jah, destroyed area by area. Within little time, the destruction of the disease surpassed that of the people of Jah and all hope left her. In the face of her family and friends, she laughed much to deny her desolate future. She spoke only of the hopes of her country and indicated nothing of her silent tribulation.

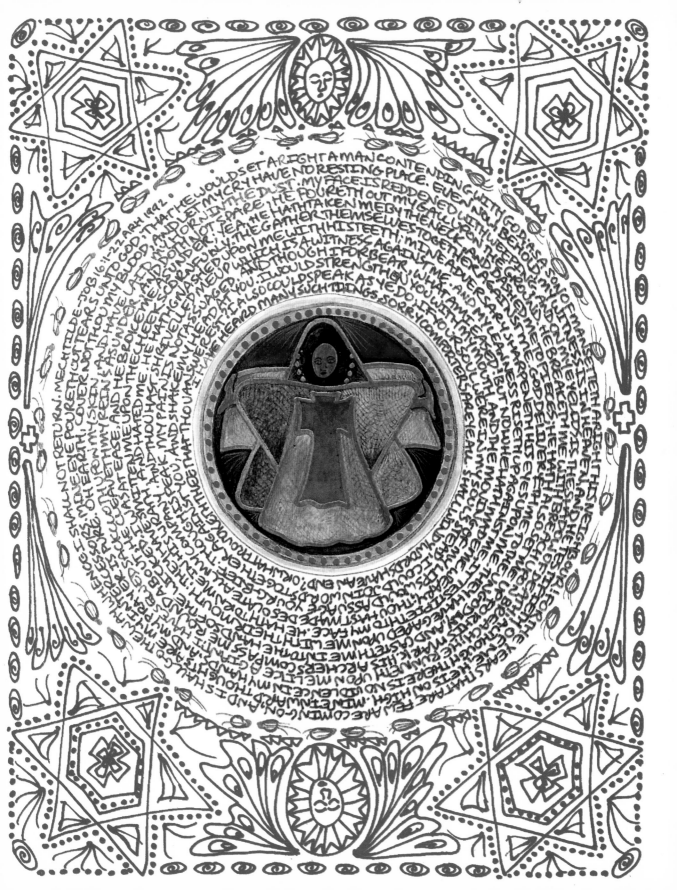

But, in the solitude of the mango tree, she lamented her misfortune. Her suffering overwhelmed her, and it was there that she cried out. There also that she heard the wails of her people. There that she begged relief from her inner turmoil and strife, and the outer ones of the Land of Jah. She pleaded mercy from pain, for herself and her country, and it was there in the shade of the tree that her tears shed in multitudes like the leaves above her.

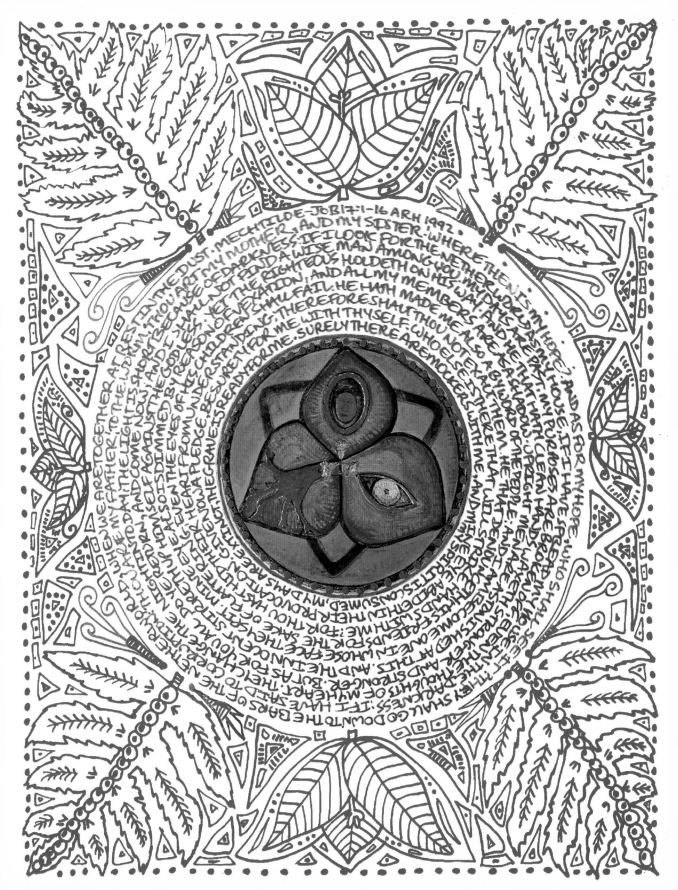

Mechtilde could bear no more. She had brought joy to her husband, her family and friends. She had worked hard in the best interest of her people. Now, with her head bent to the ground, pleading that she be swallowed up, she grew weary and succumbed to the disease. The price had been paid for her suffering, and she left the Land for another. Having bestowed upon it much more than her offspring, she then blessed it with the memory of a good name.

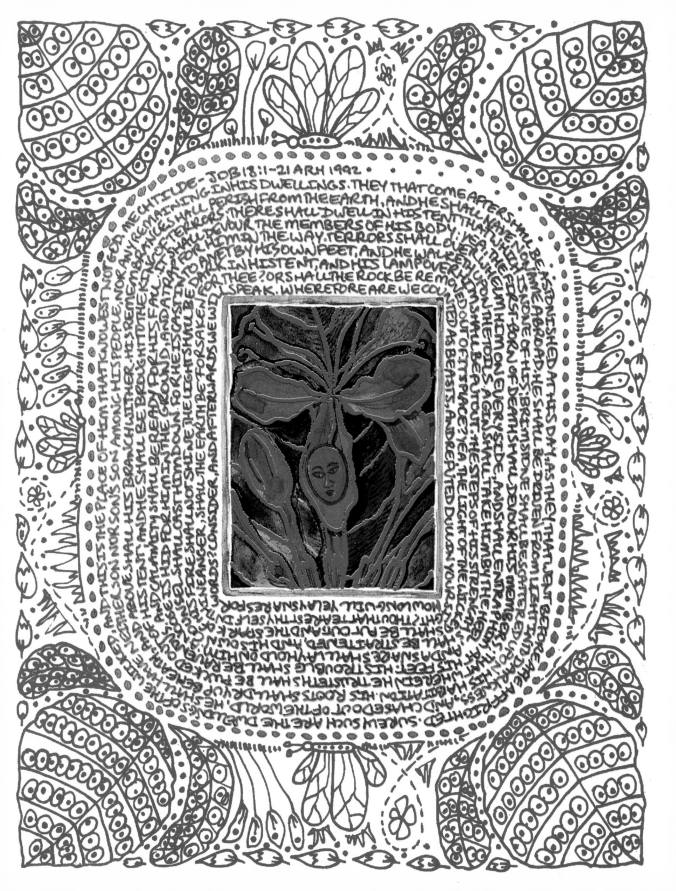

SPIRIT TREE

Break branch, break
I will not weep
while cradled
in your boughs
I cannot climb high
and cannot see
I have no fear
of Ending
in your arms

In the singing
wind
Rain offers
applause
on the cool roof
below
It washes your
young

Instead

You speak
of them
as dried-up
seeds
the fruits
of your labor
the food
of my thoughts

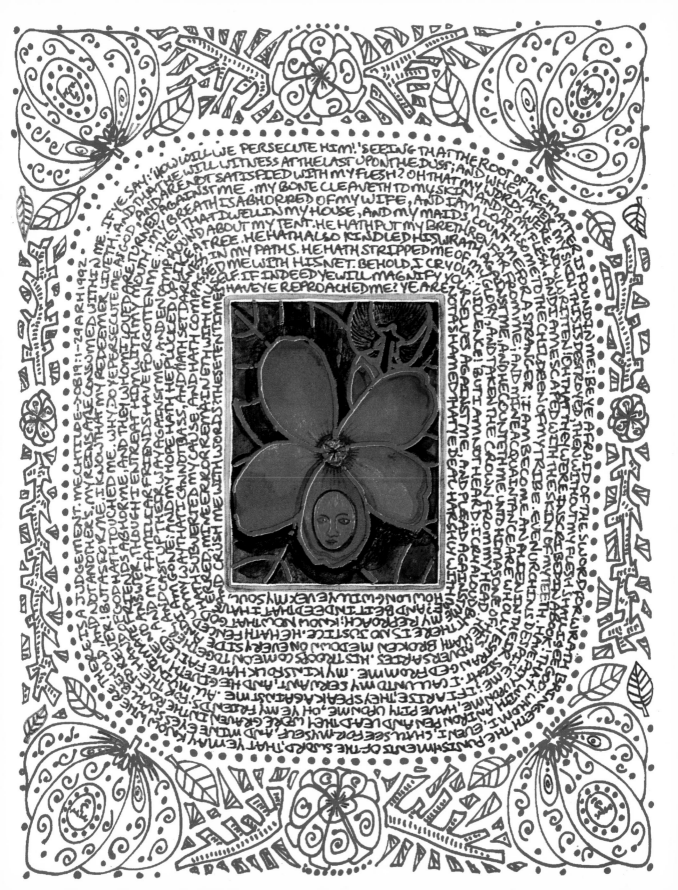

IF YE SAY: "HOW WILL WE PERSECUTE HIM!" SEEING THAT THE ROOT OF THE MATTER IS FOUND IN ME: BE YE AFRAID OF THE SWORD; FOR WRATH BRINGETH THE PUNISHMENTS OF THE SWORD, THAT YE MAY KNOW THERE IS A JUDGEMENT. ME, CHILDE — JOB 19:1-29 ARH 1992

AND HE WILL WITNESS AT THE LAST UPON THE DUST; AND WHEN AFTER MY SKIN THIS IS DESTROYED, THEN WITHOUT MY FLESH SHALL I SEE GOD. WHOM I, EVEN I, SHALL SEE FOR MYSELF, AND MINE EYES SHALL BEHOLD, AND NOT ANOTHER'S. MY REINS ARE CONSUMED WITHIN ME.

AND ARE NOT SATISFIED WITH MY FLESH? OH THAT MY WORDS WERE NOW WRITTEN! OH THAT THEY WERE INSCRIBED IN A BOOK! THAT WITH AN IRON PEN AND LEAD THEY WERE GRAVEN IN THE ROCK FOR EVER! BUT AS FOR ME, I KNOW THAT MY REDEEMER LIVETH,

TURNED AGAINST ME. MY BONE CLEAVETH TO MY SKIN AND TO MY FLESH, AND I AM ESCAPED WITH THE SKIN OF MY TEETH. HAVE PITY UPON ME, HAVE PITY UPON ME, OH YE MY FRIENDS; FOR THE HAND OF GOD HATH TOUCHED ME. WHY DO YE PERSECUTE ME AS GOD,

MY BREATH IS ABHORRED OF MY WIFE, AND I AM LOATHSOME TO THE CHILDREN OF MY TRIBE. EVEN YOUNG CHILDREN DESPISE ME; WHEN I ARISE, THEY SPEAK AGAINST ME. ALL MY INTIMATE FRIENDS ABHOR ME, AND THEY WHOM I LOVED ARE TURNED AGAINST ME.

THEY THAT DWELL IN MY HOUSE, AND MY MAIDS, COUNT ME FOR A STRANGER: I AM BECOME AN ALIEN IN THEIR SIGHT. I CALL UNTO MY SERVANT, AND HE GIVETH ME NO ANSWER; THOUGH I ENTREAT HIM WITH MY MOUTH. MY KINSFOLK HAVE FAILED,

ROUND ABOUT MY TENT. HE HATH PUT MY BRETHREN FAR FROM ME, AND MINE ACQUAINTANCE ARE WHOLLY ESTRANGED FROM ME. MY FAMILIAR FRIENDS HAVE FORGOTTEN ME, AND MY HOPE HATH HE PLUCKED UP LIKE A TREE.

A TREE. HE HATH ALSO KINDLED HIS WRATH AGAINST ME, AND HE COUNTETH ME UNTO HIM AS ONE OF HIS ADVERSARIES. HIS TROOPS COME ON TOGETHER, AND CAST UP THEIR WAY AGAINST ME, AND ENCAMP ROUND ABOUT MY TENT.

IN MY PATHS. HE HATH STRIPPED ME OF MY GLORY, AND TAKEN THE CROWN FROM MY HEAD. HE HATH BROKEN ME DOWN ON EVERY SIDE, AND I AM GONE; AND MY HOPE HATH HE PLUCKED UP LIKE A TREE. AND HATH SET DARKNESS IN MY PATHS.

SED ME WITH HIS NET. BEHOLD, I CRY OUT "VIOLENCE!" BUT I AM NOT HEARD; I CALL ALOUD, BUT THERE IS NO JUSTICE. HE HATH FENCED UP MY WAY THAT I CANNOT PASS, AND HATH SET DARKNESS

SELF. IF INDEED YE WILL MAGNIFY YOURSELVES AGAINST ME, AND PLEAD AGAINST ME MY REPROACH; KNOW NOW THAT GOD HATH SUBVERTED MY CAUSE, AND HATH COMPASSED ME WITH HIS NET.

HAVE YE REPROACHED ME? YE ARE NOT ASHAMED THAT YE DEAL HARSHLY WITH ME; THESE TEN TIMES HAVE YE REPROACHED ME, AND CRUSH ME WITH WORDS? THESE TEN TIMES

HOW LONG WILL YE VEX MY SOUL, AND CRUSH ME WITH WORDS? THESE TEN TIMES HAVE YE REPROACHED ME

AND BE IT INDEED THAT I HAVE ERRED, MINE ERROR REMAINETH WITH MYSELF.

My mother calls
I cannot hear her

I am lost
in the language
of your leaves
Loved
by the branches
of living
men
you have

met

So we speak of her
In not the same
tongue
but you
you spell out
your sentiment
See me
and feed me
again

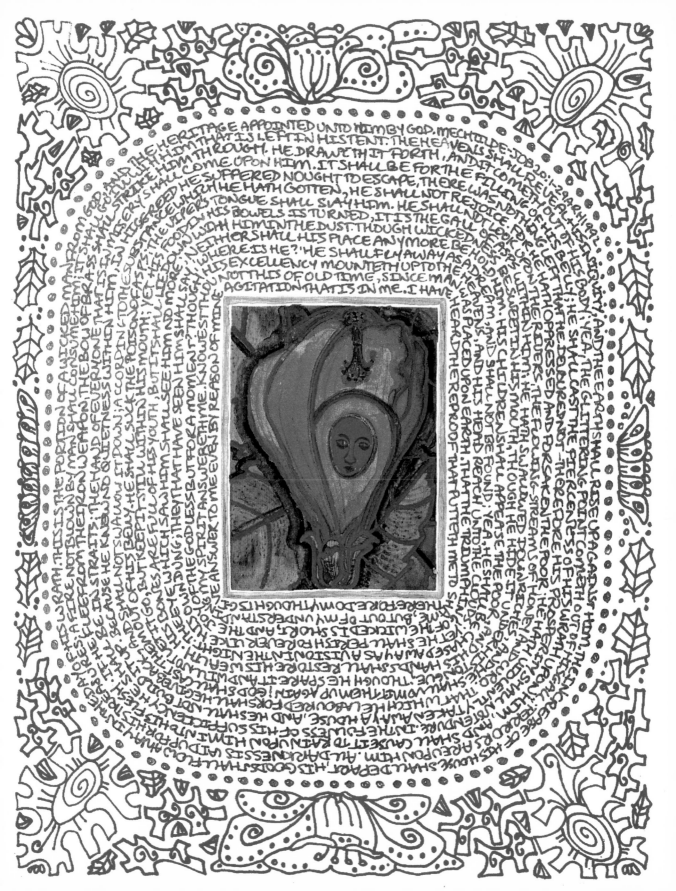

...THE HERITAGE APPOINTED UNTO HIM BY GOD. MECHTILDE · JOB 20: ...AND THE EARTH SHALL RISE UP AGAINST HIM, ...HIM THAT IS LEFT IN HIS TENT. THE HEAVENS SHALL REVEAL ...HIM THROUGH. HE DRAWETH IT FORTH, AND IT COMETH OUT OF HIS BODY, YEA, THE GLITTERING POINT COMETH OUT. THE SINS ...ERY SHALL STRIKE HIM THROUGH. ...SHALL GO IN ...FROM GOD. AND ...HIS MISERY SHALL COME UPON HIM. IT SHALL BE FOR THE FILLING OF HIS BELLY: HE SHALL CAST THE PIERCINGNESS OF HIS WRATH ...THE BOW OF BRASS SHALL STRIKE HIM ...HE HATH OPPRESSED AND FORSAKEN THE POOR; HE HATH ...UPON ...HE SUFFERED NOUGHT TO ESCAPE, THERE WAS NOTHING LEFT THAT HE SHOULD ...WITHIN HIM, IN THE MIDST OF HIS PROSPERITY ...BE IN STRAITS: THE HAND OF EVERY ONE THAT IS ...HE HATH GOTTEN, HE SHALL NOT REJOICE. FOR HE HATH ...THE VIPER'S TONGUE SHALL SLAY HIM. HE SHALL NOT LOOK UPON THE RIVERS, THE FLOWING STREAMS OF HONEY ...SUBSTANCE, AND ...FOOD IN HIS BOWELS IS TURNED, IT IS THE GALL OF ASPS WITHIN HIM: HE HATH SWALLOWED DOWN RICHES, AND ...HIS CHILDREN SHALL SEEK TO PLEASE THE POOR, AND HIS HANDS SHALL RESTORE ...WITH HIM IN THE DUST. THOUGH WICKEDNESS BE SWEET IN HIS MOUTH, THOUGH HE HIDE IT UNDER HIS TONGUE; THOUGH ...NEITHER SHALL HIS PLACE ANY MORE BEHOLD HIM. HIS CHILDREN SHALL SEEK TO PLEASE THE POOR, AND HIS HANDS SHALL RESTORE HIS ...WHERE IS HE?' HE SHALL FLY AWAY AS A DREAM, AND SHALL NOT BE FOUND: YEA, HE SHALL ...HIS EXCELLENCY MOUNT UP TO THE HEAVENS, AND HIS HEAD REACH UNTO THE CLOUDS; YET HE SHALL PERISH FOR EVER LIKE ...THOU NOT THIS OF OLD TIME, SINCE MAN WAS PLACED UPON EARTH, THAT THE TRIUMPH ...THE WICKED IS SHORT, AND THE JOY ...AGITATION THAT IS IN ME. I HAVE HEARD THE REPROOF, THAT PUTTETH ME TO SHAME ...THEREFORE DO MY THOUGHTS CAUSE ...ME, BUT OUT OF MY UNDERSTANDING ...

...OF HIS WRATH. THIS IS THE PORTION OF A WICKED MAN FROM GOD, AND THE HERITAGE ...OF HIS CONCEALED ...A FIRE NOT BLOWN BY MAN SHALL CONSUME HIM; IT SHALL GO ILL WITH HIM ...THE IRON WEAPON. THE BOW OF BRASS SHALL STRIKE HIM THROUGH, AND THE GLITTERING SWORD ...THE HAND OF EVERY ONE THAT IS IN MISERY SHALL COME UPON HIM. ALL DARKNESS IS HID IN HIS SECRET PLACES ...BECAUSE HE KNEW NO QUIETNESS WITHIN HIM, IN THE DAYS OF HIS YOUTH ...HE SHALL NOT SAVE OF THAT WHICH HE DESIRED. THERE SHALL NONE OF HIS MEAT BE LEFT; ...IT DOWN: ACCORDING TO THE SUBSTANCE ...HE SHALL SUCK THE POISON OF ASPS: ...HIS GOODS SHALL FLOW AWAY IN THE DAY OF HIS WRATH. HIS OWN INCREASE SHALL DEPART ...WHICH HE LABOURED, AND SHALL NOT SWALLOW ...HE HATH VIOLENTLY TAKEN AWAY A HOUSE WHICH HE BUILDED NOT; ...BECAUSE HE HATH OPPRESSED AND FORSAKEN THE POOR ...SURELY HE SHALL NOT FEEL QUIETNESS IN HIS BELLY, ...THOUGH HE SPARE IT, AND FORSAKE IT NOT; BUT KEEP IT STILL WITHIN HIS MOUTH: ...IN THE MIDST OF HIS SUFFICIENCY HE SHALL BE IN STRAITS ...WHEN HE IS ABOUT TO FILL HIS BELLY, GOD SHALL CAST ...UPON HIM, AND SHALL RAIN IT UPON HIM WHILE HE IS EATING. HE SHALL FLEE FROM THE IRON WEAPON ...HE THAT HAVE SEEN HIM SHALL SAY, 'WHERE IS HE?' ...THE POISON ...OF THE GODLESS, BUT FOR A MOMENT. THOUGH ...THOU KNOWEST THOU WAST THEN BORN ...IN MY SPIRIT ANSWERETH ME. KNOWEST THOU ...ME ANSWER TO ME EVEN BY REASON OF MINE

More

Make me a moment
aware

Skins sit shrivelled
on the rusted zinc
Separated from you
they die
to form new
life

But rain has wetted
the wood
Saturated, it will
no longer stand
Pink paint
washes the Earth
It swallows
our footsteps
It quenches
your thirst

...GENTLY ON HIM, AND A WHOLE PROCESSION WALKS BEHIND HIM ...THE DAY OF WRATH? BUT WHO IS THERE THEN TO ACCUSE HIM TO HIS FACE FOR HIS DEEDS AND PUNISH HIM... WHAT YOU SAY, WHERE IS THE TENT WHERE THE WICKED LIVED? YOU NEVER ASKED THOSE THAT HAVE TRAVELLED... HAVE TASTED HAPPINESS. TOGETHER NOW THEY LIE IN THE DUST WITH WORMS FOR COVERING. I KNOW WELL WHAT YOU ARE THINKING, THE HARSH CONCLUSIONS YOU DRAW... HAPPINESS AND EASE WITH HIS THIGHS ALL FULL OF MILK, AND HIS BONES ... THE FULLNESS OF HIS STRENGTH. IN ALL POSSIBLE HAPPINESS ... THE MONTHS OF HIS ... CUT OFF ... BUT CAN THE FORTUNES OF HIS HOUSE AFFECT HIM WHEN THE NUMBER OF HIS ... CHILDREN. NO! LET HIM BEAR THE PENALTY HIMSELF, AND SUFFER UNDER IT! LET HIM ... DESTROYED BY THE WRATH OF GOD? HOW OFTEN DO WE SEE HIM LIKE A STRAW BEFORE ... THEIR FORTUNE IN THEIR OWN TWO HANDS. AND IN THEIR COUNCIL. LET NO ROOM FOR GOD ... "GO AWAY! WE DO NOT CHOOSE TO LEARN YOUR WAYS. WHAT IS THE... AND THE LYRE, AND REJOICE TO THE SOUND OF THE FLUTE. THEY END THEIR ... INCREASING WITH THEIR AGE, THEIR ... TAMBOURINE AND THE PEACE OF THEIR HOUSES HAS NOTHING TO FEAR. THE GOD ... DESTROYED BY THE WRATH OF GOD? ... PLACE YOUR HANDS OVER YOUR MOUTHS. I MYSELF AM APPALLED ... AGAINST MAN? HAVE I NO REASON TO BE OUT OF PATIENCE? ... YOU CAN OFFER ME. LET ME HAVE MY SAY; YOU MAY JEER ... LISTEN ONLY TO ME ... WHEN I HAVE SPOKEN ... HEAR WHAT I HAVE TO SAY, AND ...

<!-- inner spiral -->
...AT HIS GRAVE. THE CLODS OF THE VALLEY ARE... FORTUNE SON OF DISASTER, AND CRIES... WHAT SHALL BECOME OF THE GREAT LORD... WITH BITTERNESS IN HIS SOUL... DIES... AND HEART... EVER KNOWN TASTED HAPPINESS... AND AGAIN ONE MAN... THE GREAT LORD... ANOTHER... THE ANGER OF SHADDAI... WHEN HE HAS GONE... DOES... HOW... OVERTAKING... IS IT NOT TRUE, THEY'RE GONE... YET THESE WERE NOT THE ONES WHO SAID TO GOD... BREEDING GROUND... OFFSPRING... THEY SING TO THE TAMBOURINE... DANCE LIKE DEER... BEGINS TO SHUDDER. DO HE WICKED... YOU WILL BE DUMBFOUNDED... YOU THINK I BEAR A GRUDGE... THIS IS THE CONSOLATION...

...RESCUE THE MAN'S FORTUNE... GO DOWN IN PEACE... SWEPT OFF LIKE CHAFF BEFORE... RUIN WITH HIS OWN EYES, AND DRINK... SEE A WICKED MAN'S LIGHT PUT OUT... AND THE MARROW OF HIS BONES... WHAT PROFIT SHOULD WE GET FROM... IN HAPPINESS AND GO DOWN IN PEACE... OFTEN DO YOU SEE A WICKED... FRISK LIKE LAMBS, THEIR... LET THEIR PROSPERITY ASSURED... GOD WIELDS IS NOT FOR THEM... LIVES OF THE GOD-FEARING... ITS... LEST THE WIND... DIVINE LESSONS IN WISDOM TO GOD? GIVE... AND NONSENSE ARE YOUR ANSWERS? ... WHEN HE IS ON HIS WAY TO HIS BURIAL... DOES GOD UNDERSTOOD THE TIME THE THEY TOLD... THE SIXTY TRUTH TO HIS BURIAL - JOB 21:11-34 · MARIA RIMINI 1992

Now

My tears
have dried
from their place
of rest
I see her
with the eye
in the back
of my head

Held still
for a moment
My mind is asleep
as you rock me
you rock me
(like magic)
my tree

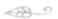

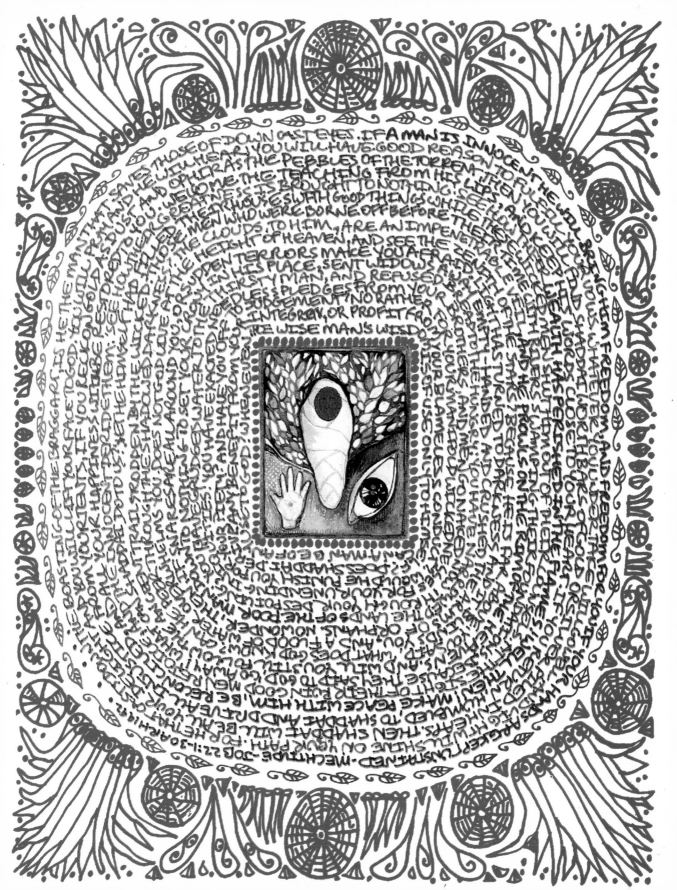

S E L A H !

Sorrow spoke

The sands on the floor

whispered

what they heard

Selah! Selah!

She is gone

No more will we see her

sit in these seats

See the back of a balding head

brush back sleep

from their eyes

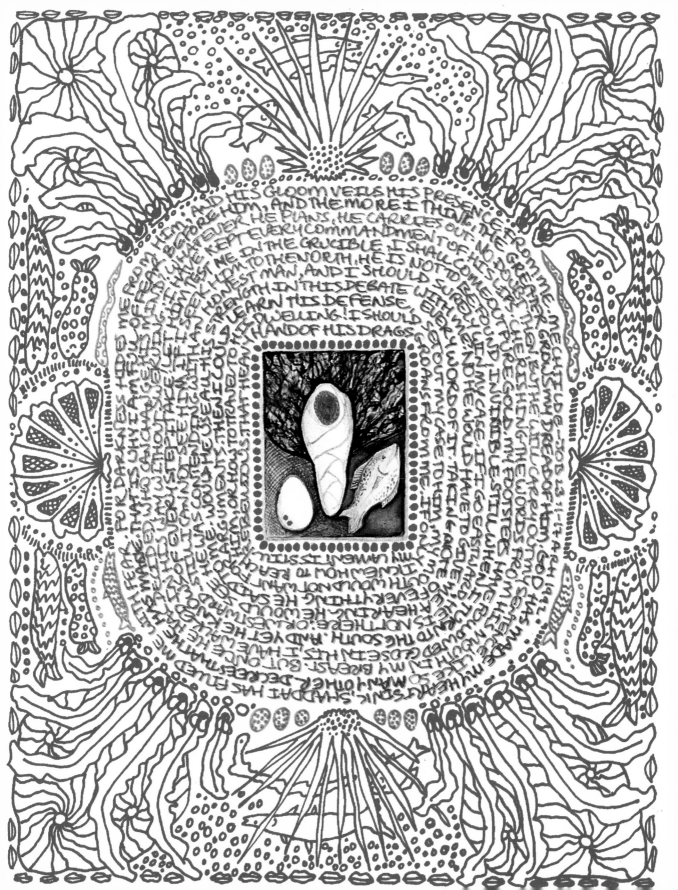

Shemang, they said
and spoke her name
Sheila! Sheila!
She is gone
In vain
they called
then sealed their lips
placing their tongues
on the wooden ground
Worded that strength
was in silence
Their pain in the thirst
of thwarted desire

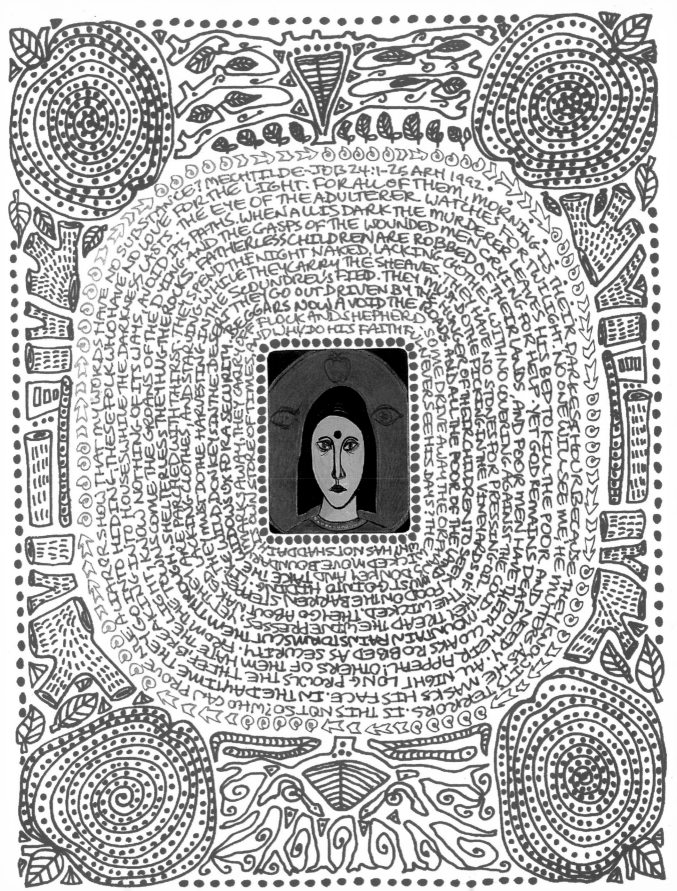

The sigh of the service

weighed upon their heads

Their presence alone

was through prayer

Their thoughts lost themselves

in the desert

stretched across the floor

An empty chair

A saddened man

The foot-made castles

in fast-receding

sand

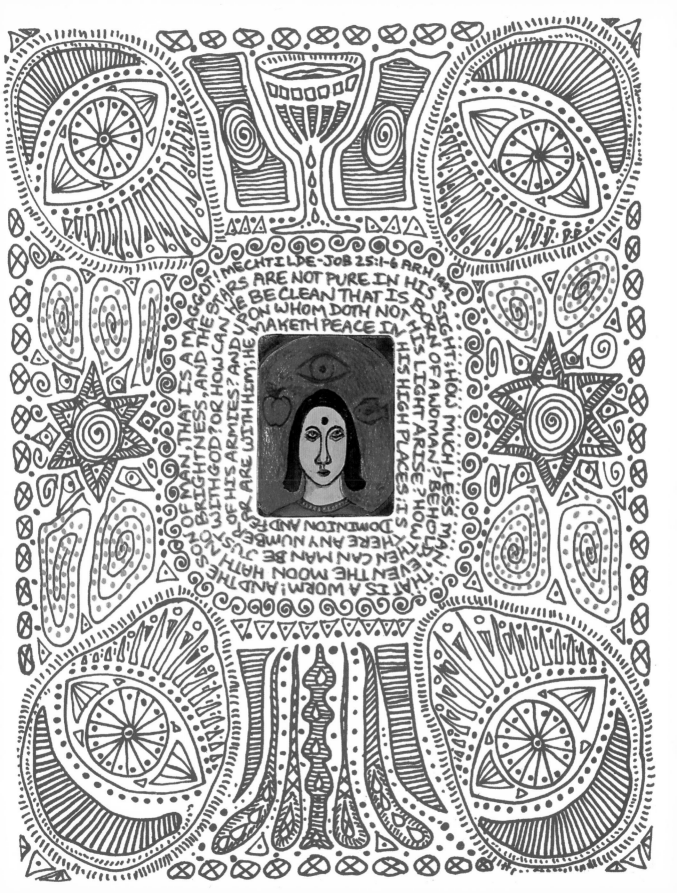

MECHTILDE–JOB 25:1–6 ARH 1997

ARE NOT PURE IN HIS SIGHT; HOW MUCH LESS MAN, THAT IS A MAGGOT, THAT IS A WORM! AND THE SON OF MAN, THAT IS A MAGGOT; THAT IS A WORM! AND THE STARS ARE NOT PURE IN HIS SIGHT; HOW MUCH LESS MAN, HE BE CLEAN THAT IS BORN OF A WOMAN? BEHOLD EVEN THE MOON HATH NO BRIGHTNESS, AND THE STARS ON WHOM DOTH NOT HIS LIGHT ARISE? HOW THEN CAN MAN BE JUST WITH GOD? OR HOW CAN A MAN BE CLEAN THAT IS MAKETH PEACE IN OF HIS ARMIES? AND UPON WHOM DOTH NOT HIS HIGH PLACES IS THERE ANY NUMBER ARE WITH HIM; HE DOMINION AND MAKETH PEACE IN

One more song

and the service was over

Suddenly, a sea

of unfamiliar faces

On bowing heads

Expressionless

On opened eyes

gazing into gaping holes

of memory

Her image

Sliding down the walls

Sinking underneath the seats

Swallowed into yellow dust

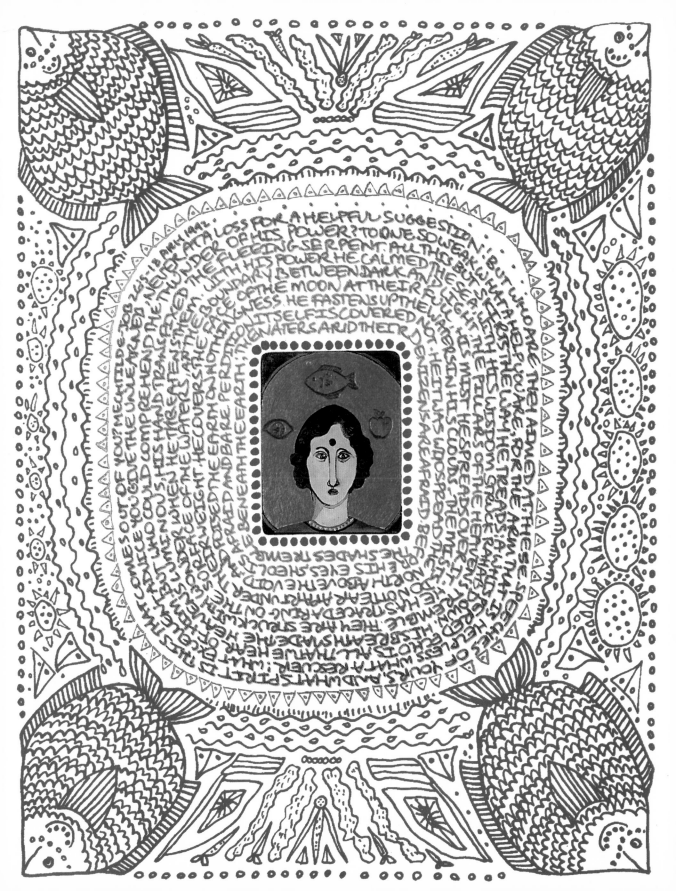

Sorrow spoke

lifting forth

her voice once more

Get up, she said

Stand up and cry!

Weep aloud

with those who are mourning, too

Lose not your tears on Jerusalem

But quench her undying thirst

Those that have seen

a thousand deaths

can celebrate themselves

So sift through the stories

Scrape the sides of the hourglass

Wash dry dust from those eyes

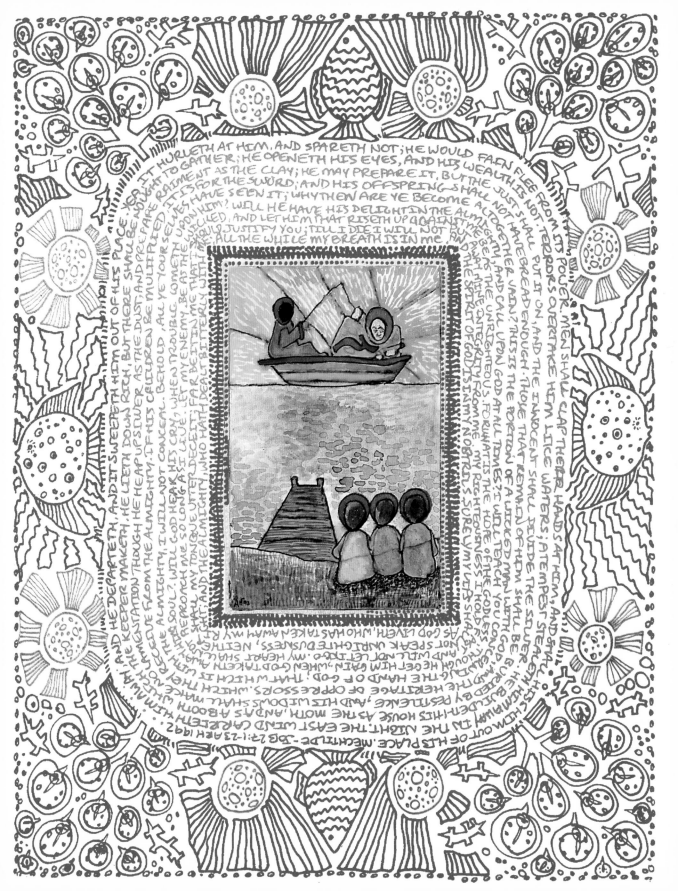

The sands sunk themselves
into floorboards
Shuffling feet
fell upon them
with little remorse
No unfulfilled lifetime
No dark, fettered
undefined sight
She sent her saint for a moment
for a fragment from each
person's heart
Accept this, she said
And I will depart

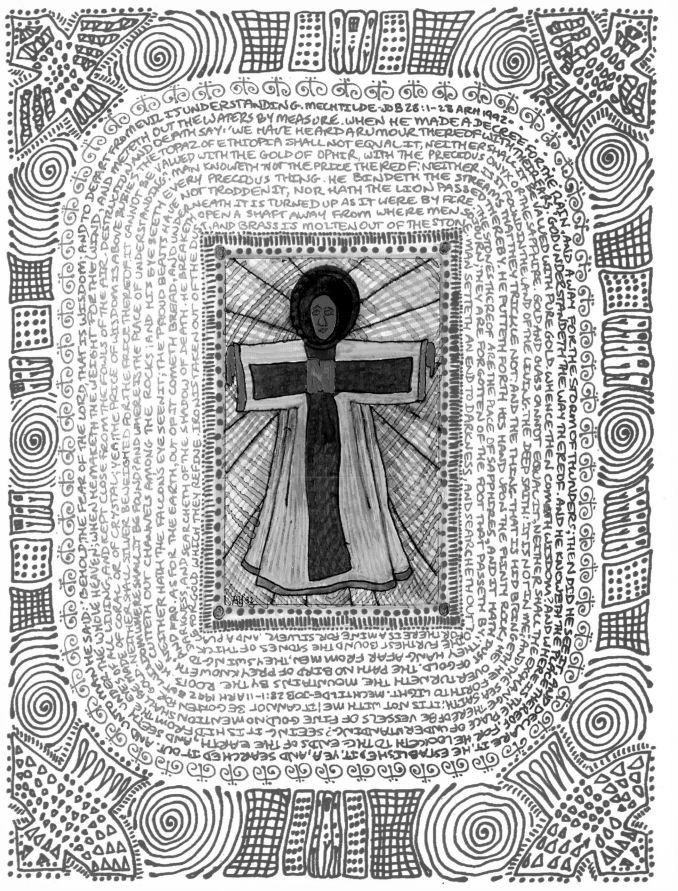

The fear of the Lord, that is wisdom; and to depart from evil is understanding. MECHTILDE JOB 28:1-28 ARH 1992

DUSK

I can only emphasize
your outline as
you slowly

sink

Manifesting
meaning

From the muddle
your body has become

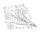

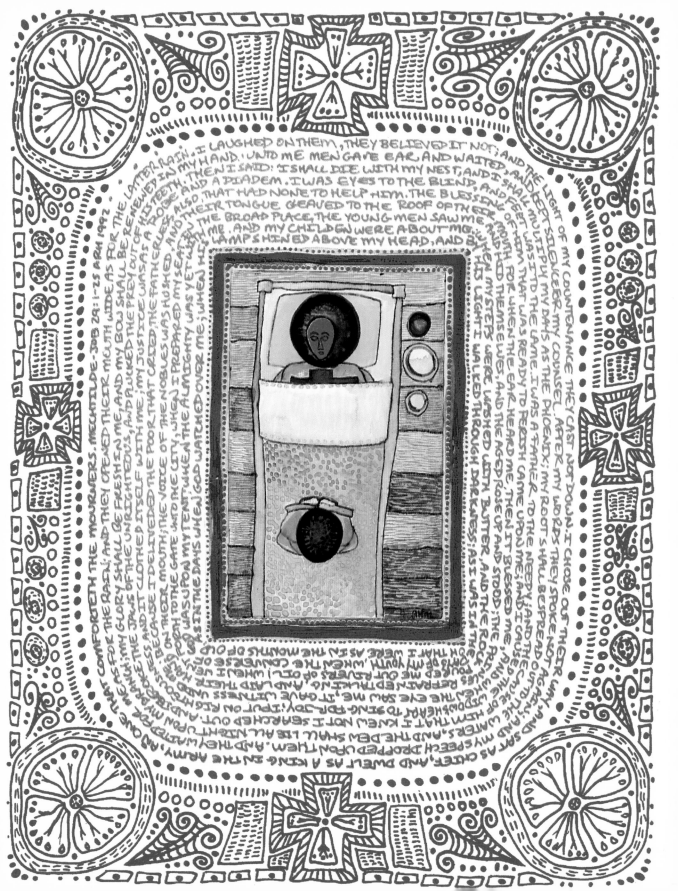

MY EYE

I see

she said

when the doctor

spoke

no more

no use

in looking

no more

The grey cloud

fixed

in her eye

can't cry

Can't cry

when we don't have

no water

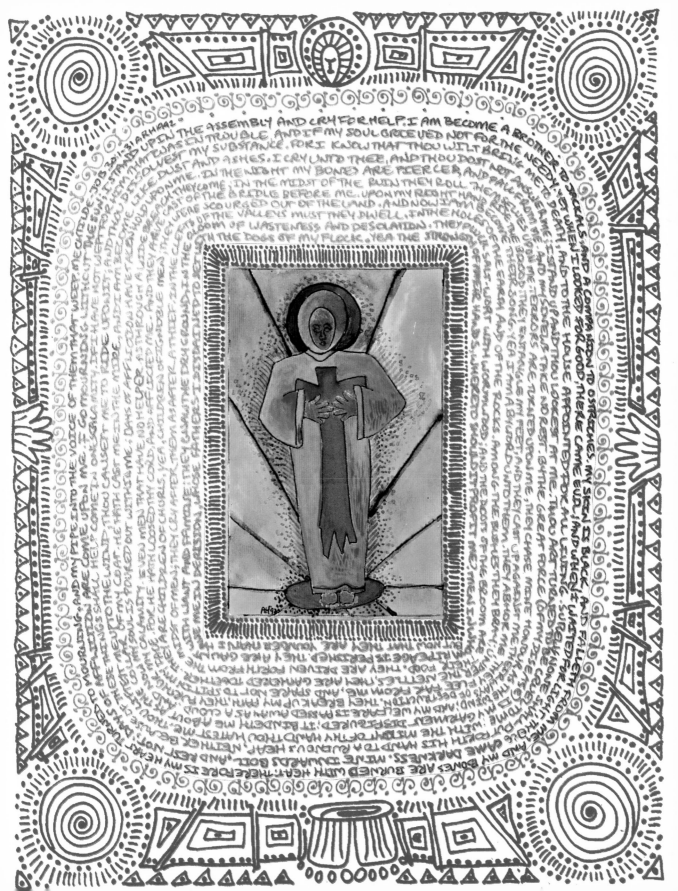

Lock off
your tears
in the city
of hope
whose riverbanks
are breaking
whose waters rise
willing their way
drilling paths
drowning the day
Have been drowned
in the drought
wrought by fear

No!

please no

A clock clicked

to pass the time

palms met hands

and prayed

Passing fingers

strove

to see

the hour drifting in

No! not yet

no rain

not the right time of year

not ready

prepared

not ready

to feel

what you are ready

to show me

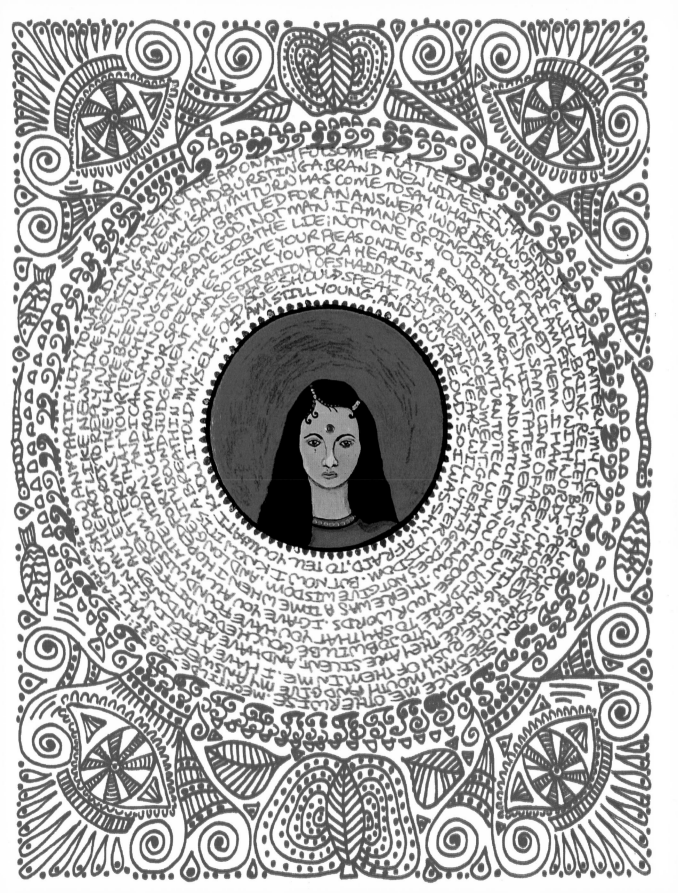

They placed
the braille clock
on the floor
Unfolded her fingers
Crossed her hands
Covered
her breastless chest
Brought her lids
down together
to rest
Her dry eyes
brought
to dreaming

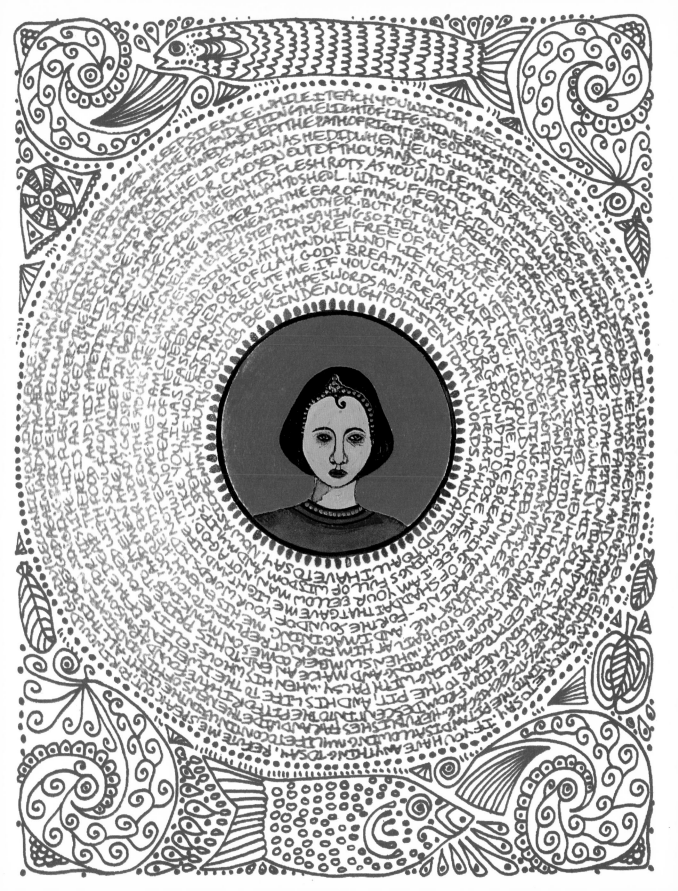

Darkness

The sun had gone

down

Silence

The city

to sleep

I see

she said softly

I understand

unable to greet

the morning

You see

she said

what you told

me to see

I saw

she looked

no more

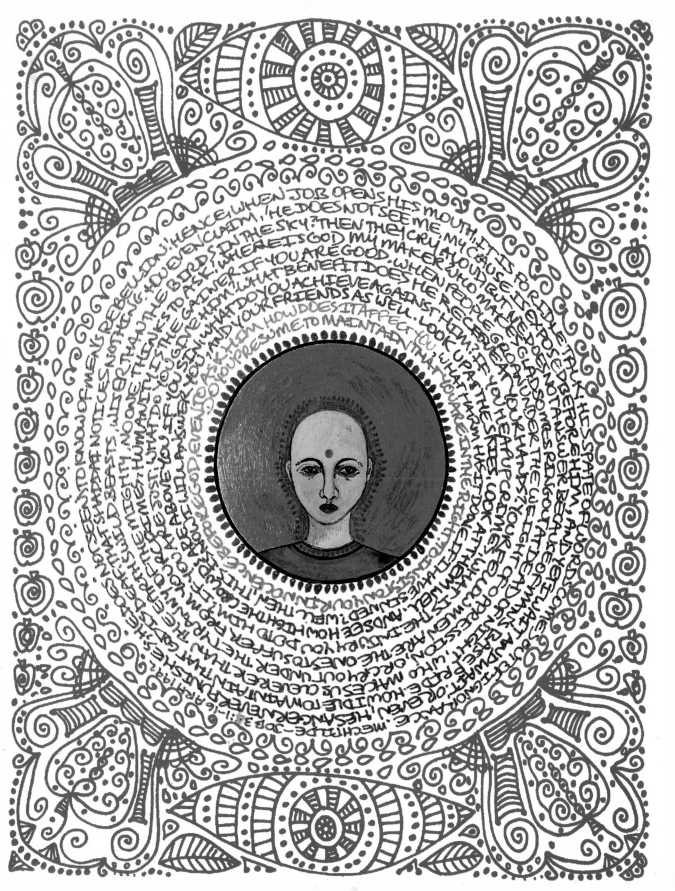

THE CRAB

Beady-eyed

Brittle-shelled

Shifty

Scavenger

Emerge from the

Sand

Meet my eyes

Square-on

No sideways

Scattersand

Getaway

Glance

But break that

Bowlegged

Backsided

Stance

of the Beast

Within

My Other

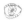

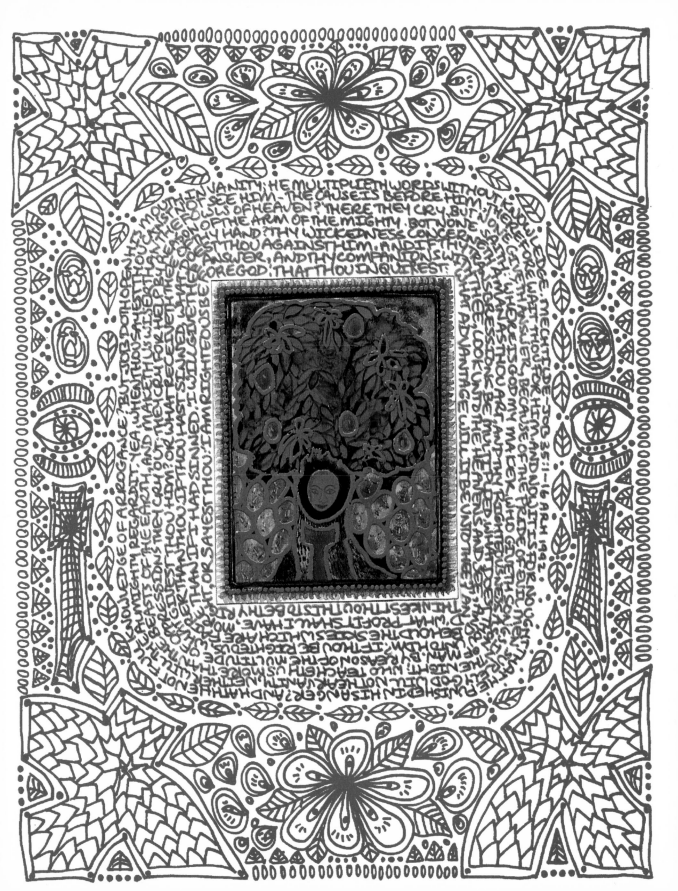

M R S. M O O N

Mrs. Moon

She is off the island
At the moment
I am told

No, Mister
Let me look
Let me light it if I want to
Let me slice it if I want to
Yes, Mista
It's my country
And my corpse is your corpse, too

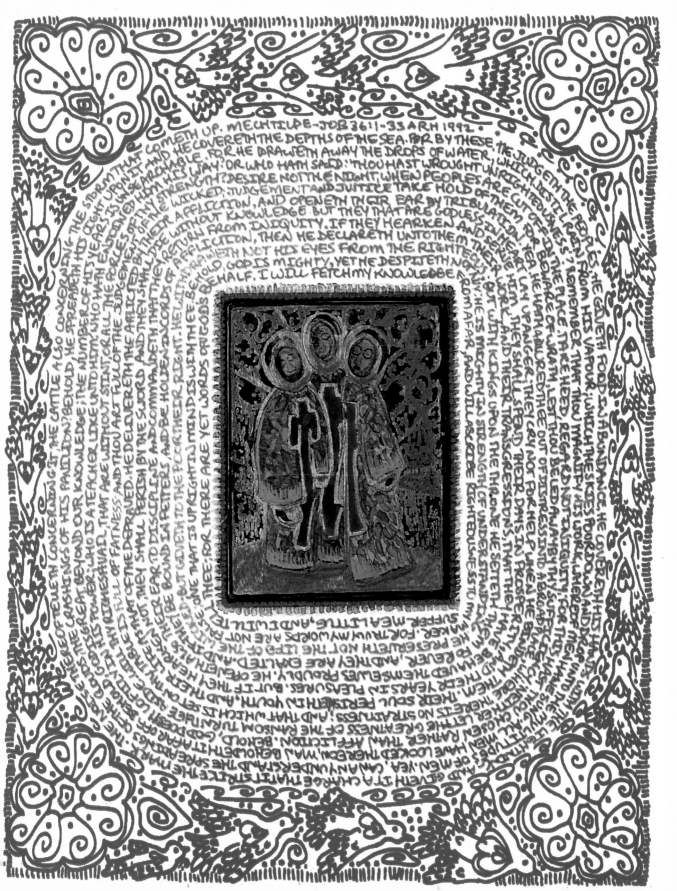

...COMETH UP. MECHTILDE - JOB 36:11-33 A.R.H. 1992 · THE JUDGETH THE PEOPLES, HE GIVETH FOOD IN ABUNDANCE. HE COVERETH HIS HANDS WITH THE LIGHTNING; AND COMMANDETH IT... FOR BY THESE HE DRAWETH AWAY THE DROPS OF WATER, WHICH DISTIL RAIN FROM HIS VAPOUR; WHICH THE SKIES POUR DOWN AND DROP UPON MAN ABUNDANTLY. THE STORM THAT COMETH UP. AND HE COVERETH THE DEPTHS OF THE SEA. OR WHO HATH SAID: "THOU HAST WROUGHT UNRIGHTEOUSNESS"? REMEMBER THAT THOU MAGNIFY HIS WORK, WHEREOF MEN HAVE SUNG. ALL MEN HAVE LOOKED IN HIS WAY; OR WHO HATH SAID: "THOU HAST WROUGHT UNRIGHTEOUSNESS"? REMEMBER THAT THOU MAGNIFY HIS WORK, WHEREOF MEN HAVE SUNG. TAKE HEED, REGARD NOT INIQUITY; FOR THIS HAST THOU CHOSEN RATHER THAN AFFLICTION. BEHOLD, GOD DOETH LOFTILY IN SEARCH AGAIN. FOR HE DRAWETH UP THE DROPS OF HIS STRENGTH? DESIRE NOT THE NIGHT, WHEN PEOPLES ARE CUT OFF IN THEIR PLACE. TAKE HEED, LEST THOU BE LED AWAY BY THY SUFFICIENCY; FOR GREAT IS THE RANSOM TURN NOT ASIDE TO DO THE NUMBER OF HIS YEARS IS UNSEARCHABLE. THE WICKED; JUDGEMENT AND JUSTICE TAKE HOLD OF THEM. HE WITHDRAWETH NOT HIS EYES FROM THE RIGHTEOUS, AND THEY ARE EXALTED; AND THAT WHICH IS SET ON MY TONGUE LET HIM HIS WAY; OR WHO CAN... HE HARM ALLUREDTHE OUT OF DISTRESS INTO A BROAD PLACE, WHERE THERE IS NO STRAITNESS; AND THAT WHICH IS SET ON MY TONGUE THE NUMBER... WICKED; JUDGEMENT AND JUSTICE TAKE HOLD OF THEM. LAY UPON GOD. THEY CRY NOT FOR HELP WHEN HE BINDETH THEM. THEIR SOUL PERISHETH IN YOUTH, AND THEIR LIFE WITH THE WHO IS A TEACHER LIKE UNTO HIM, THAT ARE WITHOUT STRAITER LAY UPON GOD. THEY CRY NOT FOR HELP WHEN HE BINDETH THEM. THEIR SOUL PERISHETH IN YOUTH, AND THEIR LIFE WITH THE UNCLEAN. HE DELIVERETH THE AFFLICTED BY AFFLICTION, AND OPENETH THEIR EAR BY TRIBULATION. YEA, HE HATH ALLURED THEE OUT OF DISTRESS INTO A BROAD PLACE, WHERE THERE IS NO STRAITNESS; AND THAT WHICH IS SET ON MY TABLE SHALL BE FULL OF FATNESS. AND THOU ART FULL OF THE JUDGEMENT OF THE WICKED; JUDGEMENT AND JUSTICE TAKE HOLD THEM. BUT THEY THAT ARE GODLESS IN HEART LAY UP ANGER; THEY CRY NOT FOR HELP WHEN HE BINDETH THEM. THEIR SOUL PERISHETH IN YOUTH, AND THEIR LIFE AMONG THE UNCLEAN. HE DELIVERETH THE POOR IN HIS AFFLICTION, AND OPENETH THEIR EAR BY TRIBULATION. FROM INIQUITY. IF THEY HEARKEN AND SERVE HIM, THEY SHALL SPEND THEIR DAYS IN PROSPERITY, AND THEIR YEARS IN PLEASURES. BUT IF THEY HEARKEN NOT, THEY SHALL PERISH BY THE SWORD, AND THEY SHALL DIE WITHOUT KNOWLEDGE. BUT THEY THAT ARE GODLESS AFFLICTION, THEN HE DECLARETH UNTO THEM THEIR WORK, AND THEIR TRANSGRESSIONS, THAT THEY HAVE BEHAVED THEMSELVES PROUDLY. HE OPENETH ALSO THEIR EAR TO DISCIPLINE, AND COMMANDETH THAT THEY RETURN FROM INIQUITY. WITHDRAWETH NOT HIS EYES FROM THE RIGHTEOUS; BUT WITH KINGS UPON THE THRONE HE SETTETH THEM FOR EVER, AND THEY ARE EXALTED. AND IF THEY BE BOUND IN FETTERS, AND BE HOLDEN IN CORDS OF AFFLICTION, THEN HE BEHALF. I WILL FETCH MY KNOWLEDGE FROM AFAR, AND WILL ASCRIBE RIGHTEOUSNESS TO MY MAKER. FOR TRULY MY WORDS ARE NOT FALSE: ONE THAT IS PERFECT IN KNOWLEDGE IS WITH THEE. BEHOLD, GOD IS MIGHTY, YET HE DESPISETH NOT ANY; HE IS MIGHTY IN STRENGTH OF UNDERSTANDING. HE PRESERVETH NOT THE LIFE OF THE WICKED; BUT GIVETH TO THE AFFLICTED THEIR RIGHT. HE SUFFER ME A LITTLE, AND I WILL SHEW THEE THAT I HAVE YET TO SPEAK ON GOD'S BEHALF...

Mrs. Moon

Don't let us go from your gaze
Don't let us fall from your light
We are your sheep, Mrs. Moon

I hated the night
I hated the night for leaving
For sending out the sun
For where she watched over us was gone
Where she closed our eyes
with song
Was no longer heard

SUPREME IN POWER, IN EQUITY, EXCELLING IN JUSTICE, YET NO OPPRESSOR - NO WONDER THAT MEN FEAR HIM, AND THOUGH WISE MEN REVERE HIM... WHEN THE LIGHT VANISHES BEHIND DARKENING CLOUDS, WHEN COMES THE WIND SWEEPING THEM AWAY, AND BRIGHTER... CAN YOU HELP HIM TO SPREAD THE VAULT OF HEAVEN, OR TEMPER THAT MIRROR OF CAST METAL? TELL ME WHAT WE... WIND, CLOUDS MAKE THE LIGHTNING FLASH? CAN YOU TELL HOW HE HOLDS THE CLOUDS IN BALANCE, A MIRACLE OF HIS... WHETHER FOR PUNISHING EARTH'S PEOPLES OR FOR A WORK OF MERCY, HE DISPATCHES THEM, LISTEN... FROM CLOUDS RADIATE HIS LIGHTNING, DIRECTING THEIR WHEELING MOTION, DIRECTLY... ON OF THE SOUTH, AND THE NORTH WINDS USHER IN THE COLD. GOD BREATHES, AND THE ICE IS THERE... STRIVINGS TO A STANDSTILL SO THAT EACH MUST ACKNOWLEDGE HIS HAND AT WORK, ALL THE BEASTS... VOICE, THE PEAL OF GOD'S MAJESTIC THUNDER. HE DOES NOT CHECK HIS THUNDER, AND HE... TO THE BLAST OF HIS VOICE AND THE SOUND THAT ISSUES FROM HIS MOUTH. HE HURLS HIS LIGHTNING...

AT THIS MY OWN HEART QUAKES AT...

...FORTH UNTIL HIS VOICE RESOUNDS. NO DOUBT OF IT, BUT GOD REVEALS WONDERS AND LEAPS FROM ITS PLACE. LISTEN, OH LISTEN... 'FALL ON THE EARTH', OR TELLS THE RAIN TO POUR DOWN IN TORRENTS, HE BRINGS ALL MEN'S... THE SURFACE OF THE WATERS FREEZES OVER. HIS... THE BEASTS RETREAT, TAKING SHELTER IN THEIR LAIRS. THE STORM WIND COMES FROM THE... SEASONAL CHANGES. THEY CARRY OUT HIS ORDERS. CAN YOU TELL HOW GOD CONTROLS THEM, OR HOW HIS... NO BACKSLIDING - NOW I MEDITATE ON GOD'S... WEIGHS THE CLOUDS DOWN WITH MOISTURE, AND THE... 'WHEN YOUR CLOTHES ARE HOT TO YOU... ORDER IN THE LETTER ALL OVER HIS INHABITED... WONDERS. CAN YOU TELL HOW GOD CONTROLS HIS... YOUR BODY, AND THE EARTH LIES STILL UNDER THE SOUTH... REPROVE YOU, OR BRINGS YOU TO TRIAL? THERE ARE TIMES... HIS COMMANDS REACH HIS EARS? THERE ARE... IN WHAT SPLENDOUR, HE, SHADDAI, IS FAR FROM OUR REACH...

FROM THE NORTH, GOD IS CLOTHED IN... AWE, MEDITATE - JOB 37: 1-24 / AFRY 1992

GOD IS CLOTHED IN FEARFUL SPLENDOUR... WE HOLD HIM IN AWE.

Wash over us
With outstretched arms, she watched over us

And Ray was the last to be touched
Held in the watery waves of light
She swam amongst its beams

But Mel
She
hid in the shadows
For fear of herself
It is she who should have been placed
in the middle
Mourn
Mourn, Mel
Her head turned away
Sing Mel. Sing again
Softly, she carried no tune

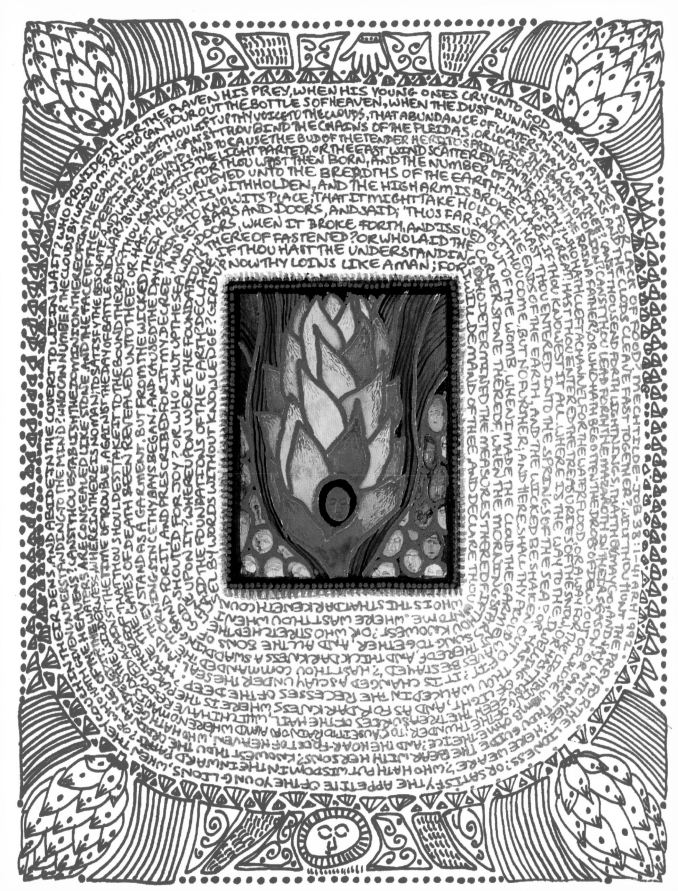

Mrs. Moon

Fall

Fall for us
Mrs. Moon
We grow strong
We grow strong in the shadows
Your shadows
My strength surrounds me

I saved my tears for you

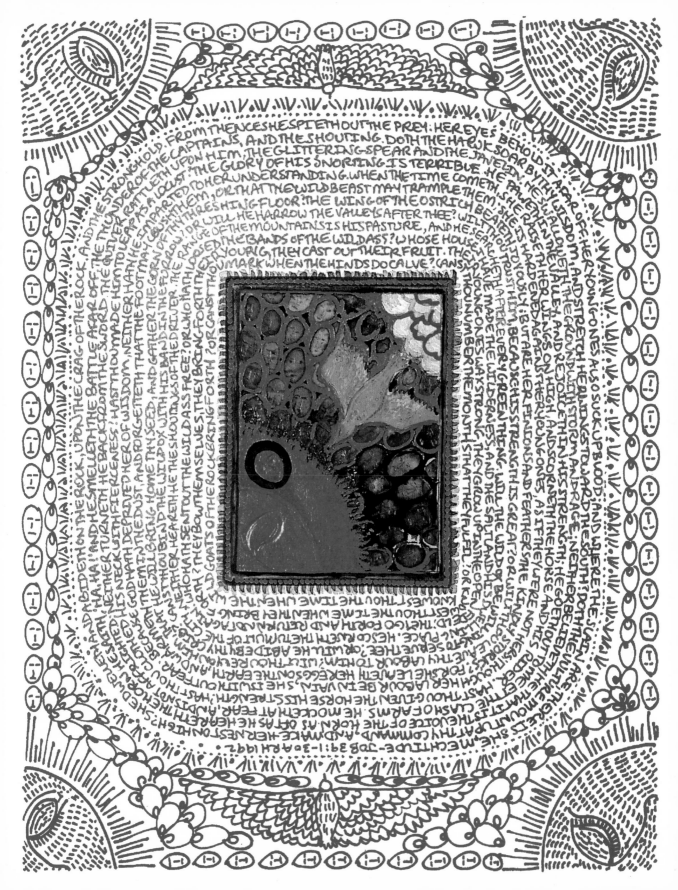

...STRONGHOLD. FROM THENCE SHE SPIETH OUT THE PREY: HER EYES BEHOLD IT AFAR OFF. HER YOUNG ONES ALSO SUCK UP BLOOD: AND WHERE THE SLAIN ARE, THERE IS SHE. ...OF THE CAPTAINS, AND THE SHOUTING. DOTH THE HAWK SOAR BY THY WISDOM, AND STRETCH HER WINGS TOWARD THE SOUTH? DOTH THE EAGLE MOUNT UP AT THY COMMAND, AND MAKE HER NEST ON HIGH? SHE DWELLETH AND ABIDETH ON THE ROCK, UPON THE CRAG OF THE ROCK, AND THE STRONGHOLD.

THUNDER OF THE CAPTAINS, AND THE SHOUTING. DOTH THE HAWK... HE PAWETH IN THE VALLEY, AND REJOICETH IN HIS STRENGTH: HE GOETH ON TO MEET THE ARMED MEN. THE GLITTERING SPEAR AND THE JAVELIN. THE GLORY OF HIS SNORTING IS TERRIBLE. HE MOCKETH AT FEAR, AND IS NOT AFFRIGHTED; NEITHER TURNETH HE BACK FROM THE SWORD. THE QUIVER RATTLETH AGAINST HIM, HE SWALLOWETH THE GROUND WITH FIERCENESS AND RAGE: NEITHER BELIEVETH HE THAT IT IS THE SOUND OF THE TRUMPET.

...DEPARTED TO HER UNDERSTANDING. WHEN THE TIME COMETH, SHE LIFTETH UP HERSELF ON HIGH, AND SCORNETH THE HORSE AND HIS RIDER. HAST THOU MADE HIM TO LEAP AS A LOCUST? THE GLORY OF HIS NOSTRILS IS TERRIBLE... OR THAT THE WILD BEAST MAY TRAMPLE THEM. SHE IS HARDENED AGAINST HER YOUNG ONES, AS IF THEY WERE NOT HERS: HER LABOUR IS IN VAIN WITHOUT FEAR; BECAUSE GOD HATH DEPRIVED HER OF WISDOM, NEITHER HATH HE IMPARTED TO HER UNDERSTANDING.

WILT THOU TRUST HIM BECAUSE HIS STRENGTH IS GREAT? OR WILT THOU LEAVE THY LABOUR TO HIM? ...OR THE THRESHING FLOOR. THE WING OF THE OSTRICH BEATETH... WILT THOU BELIEVE HIM, THAT HE WILL BRING HOME THY SEED, AND GATHER THE CORN OF THY FLOOR? OR WILL HE HARROW THE VALLEYS AFTER THEE? WILT THOU TRUST HIM...

...OR WILL HE ABIDE BY THY CRIB? CANST THOU BIND THE UNICORN WITH HIS BAND IN THE FURROW? OR WILL HE HARROW THE VALLEYS AFTER THEE?... THE RANGE OF THE MOUNTAINS IS HIS PASTURE, AND HE SEARCHETH AFTER EVERY GREEN THING. WILL THE UNICORN BE WILLING TO SERVE THEE, OR ABIDE BY THY CRIB?

...KNOWEST THOU THE TIME WHEN THE WILD GOATS OF THE ROCK BRING FORTH? OR CANST THOU MARK WHEN THE HINDS DO CALVE? (ANS) HE MOCKETH AT FEAR, AND IS NOT AFFRIGHTED; ...THE MULTITUDE OF THE CITY, NEITHER REGARDETH HE THE CRYING OF THE DRIVER. ...WILL THE WILD ASS FREE? OR WHO HATH LOOSED THE BANDS OF THE WILD ASS? WHOSE HOUSE I HAVE MADE THE WILDERNESS, AND THE BARREN LAND HIS DWELLING. HE SCORNETH THE MULTITUDE OF THE CITY...

...THEY GO FORTH, AND RETURN NOT UNTO THEM. ...FOR SHE LEAVETH HER EGGS IN THE EARTH, AND WARMETH THEM IN THE DUST, AND FORGETTETH THAT THE FOOT MAY CRUSH THEM... CANST THOU NUMBER THE MONTHS THAT THEY FULFIL? OR KNOWEST THOU THE TIME WHEN THEY BRING FORTH?

THEY BOW THEMSELVES, THEY BRING FORTH THEIR YOUNG ONES, THEY CAST OUT THEIR FRUIT. THEIR YOUNG ONES ARE IN GOOD LIKING, THEY GROW UP WITH CORN; THEY GO FORTH... HAST THOU GIVEN THE HORSE HIS STRENGTH? HAST THOU CLOTHED HIS NECK WITH THUNDER? CANST THOU MAKE HIM AFRAID AS A GRASSHOPPER?

SCRIPTURE - JOB 39:1-30 A.R.H 1992

ECLIPSE

A sad sun
brightened
my day today; I
recognized the face
as it slowly crept in
through the clouds;
I grasped its features
But it guardedly
gazingly
faded
away

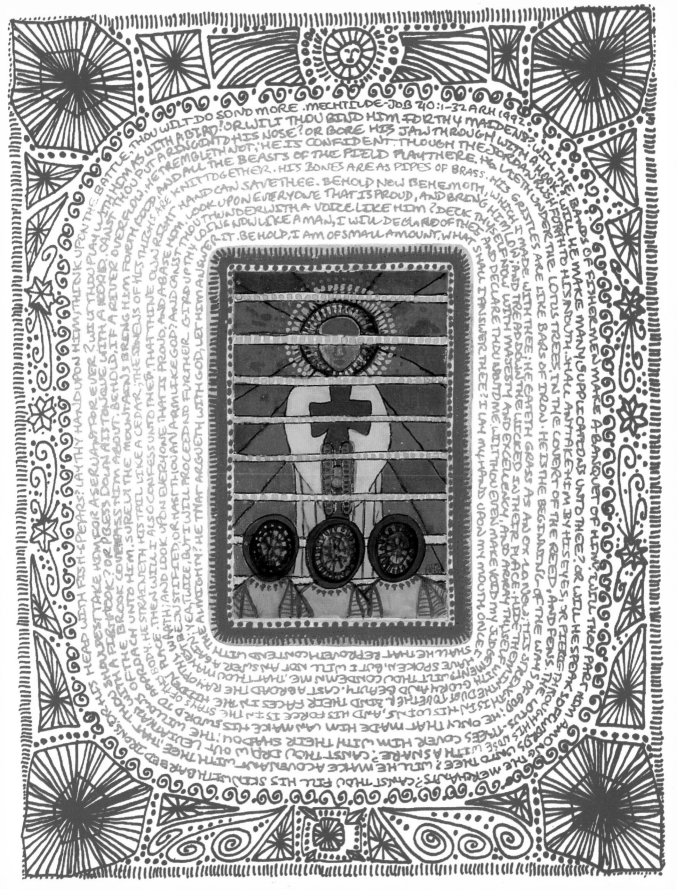

DUPPY PRAYER

Through my eyes
Closed to light
Is the vision
Of you, not me
Yes it's you
With the powder-grey
Hairless head
Of you, not she
With the bumpy-blue
Breastless chest
And me
With the vision
Of you
Lying there
Sheetly-white
Sheet-to-white
Whites-of-eyes
Peering
Feet forth
For me
She said
At the sight
Of her daughter
In fear
Lying in fear
Of herself

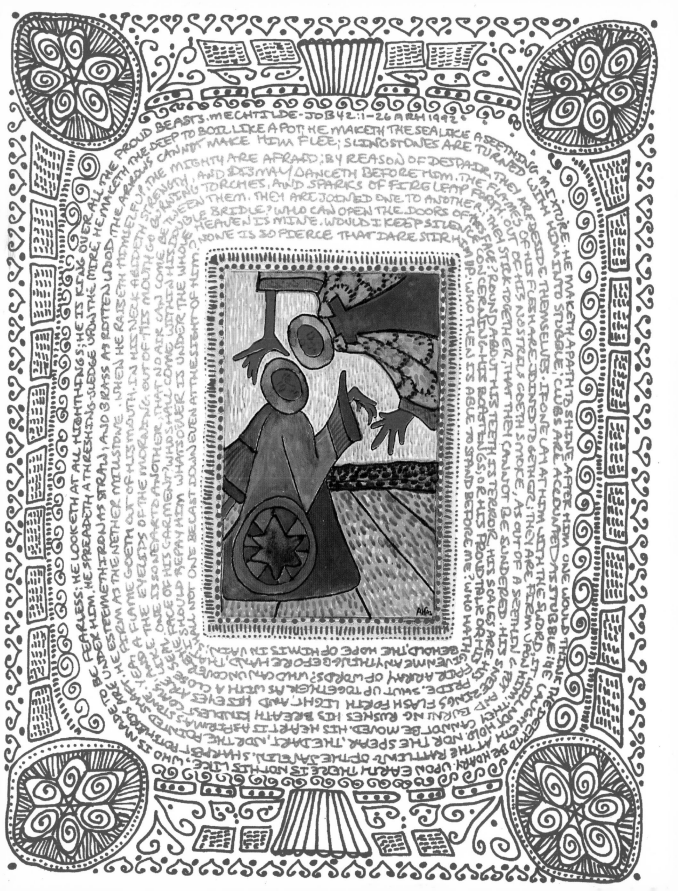

Jesus Peace
Is this what you die for
Part of what one must become
Duppy Kingdom
Where no one
Can sleep
Fright-filled
Of themselves and
Their hapless heads
Chests beating
Breaths rising
Breasts falling
For Duppy
Duppy Kingdom
Done come?

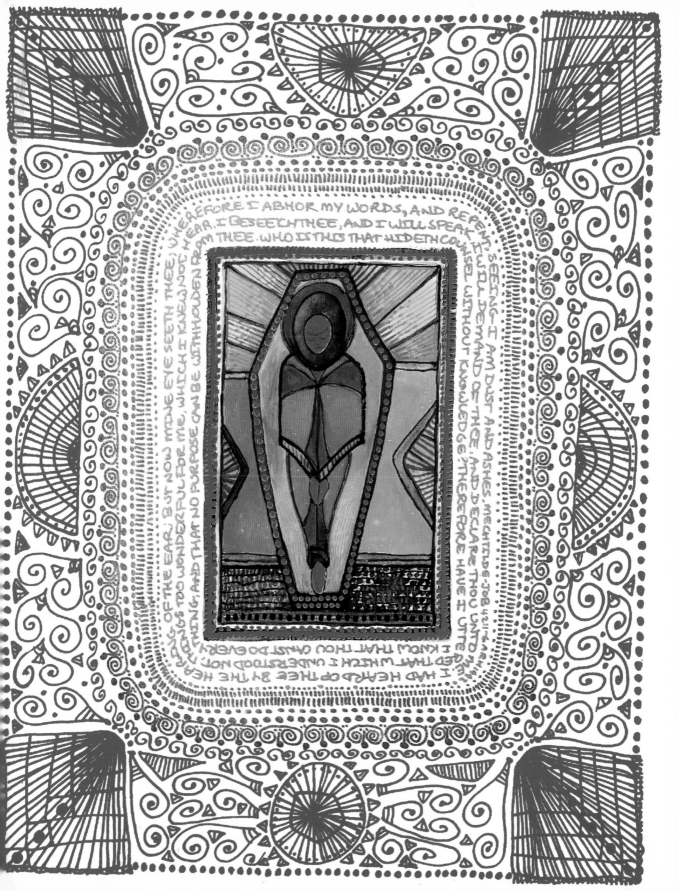

Lord God

Give me rest

Let me sleep

Seal my eyes

To the night

To that Kingdom

Of yours

That Kingdom

Has come

Amen

AUTHOR'S NOTE

My father told me, not so long ago, that the worst day of his life was the day my mother was diagnosed with cancer. Breast cancer. In 1969. On that day, he mourned as he had never mourned before. My younger sister was one, I was two, my elder sister three years old. After that day, he told me, a darkness lifted, and each succeeding day became a private thanksgiving, a celebration of life itself, that she was still with him, and us. Up to her death, nine years later. In 1978. When a cloud descended over me. Remaining until I too could treasure her life, see her as a blessing that once was, and not simply as a loss. The journey takes place in this book.

I wrote it for my father and my sisters, for whom the pain of losing a wife and a mother in the morning sun of life was almost too great.

And for my stepmother, in that by imparting my sentiment in its entirety to this work I could now let go and love her without the shadow cast by unresolved emotions.

Then for my grandparents, whose nurturing presence throughout its formation allowed me to lose myself, let myself be absorbed by history, within the parameters of their daily routine, but with utter freedom, and accept my mother's death.

And finally for her family, friends, acquaintances, and all for whom, because of her absence, the sky still carries a shade of grey . . .

A NOTE ABOUT THE AUTHOR

Anna Ruth Henriques was born in 1967 in Kingston, Jamaica.
She is an artist who has shown in exhibitions in the Caribbean,
the United States, and Europe. She currently lives with her
husband in Tokyo.

A NOTE ON THE TYPE

The text of this book was set in Frutiger, a typeface designed
by Adrian Frutiger in 1976. It was originally named Roissy and
was designed for use in the Charles de Gaulle Airport at Roissy
in France.

The serif typeface used to accompany Frutiger is Centaur, the
only typeface designed by Bruce Rogers (1870–1957), the well-
known American book designer.

Color separations by Ultragraphics, Ltd., Dublin, Ireland
Printed and bound by Berryville Graphics, Berryville, Virginia
Designed by Abby Weintraub

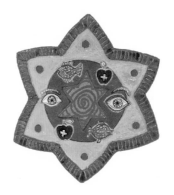